D0902764

# VIDEO FAMILY PORTRAITS

### THE USER FRIENDLY GUIDE
### TO VIDEO TAPING YOUR FAMILY HISTORY,
### STORIES, & MEMORIES!

*\* Interviewing and Video Tips \**

*\* Family History Question Guide \**

*\* Copying Home Movies Onto Video \**

*\* Video Taping Special Occasions \**

*and more!*

**ROB HUBERMAN**     \*     **LAURA JANIS**

HERITAGE BOOKS, INC.
Bowie, MD

Layout and design by Communication Techniques, Washington, DC
Cover by Mark Seidler
Illustrations by Debra Malovany

First printing September 1987
Second printing March 1988

ISBN 1-55613-074-0

Published by

## HERITAGE BOOKS, INC.
1540 E Pointer Ridge Place
Bowie, MD 20716
(301) 390-7708

A complete catalog listing hundreds
of titles on History, Genealogy, & Americana
is available free upon request.

*To Our Families ...*

# CONTENTS

## 8 VIDEO TAPING "SPECIAL OCCASIONS"

## 9 FAMILY HISTORY QUESTION GUIDE

## 10 DISCOVERING "OTHER" FAMILY ROOTS

# ACKNOWLEDGMENTS

I would like to thank Alan Sorkowitz for his publishing advice during the development of this book, his editorial contributions to the final manuscript, and especially, for his long-time friendship. Thanks also to Gerald Bagg for his marketing efforts and to Bob Davies, whose guidance in the field of video helped shape my career. A special thanks to my brother Brad, who provided me with essential "tools of the trade" and other elements of support for carrying out this project. Equally, a special thanks to my brother Mitch for his promotional expertise and advice. A very special thanks to Laura, whose contributions and efforts have helped to turn a dream into reality. Most of all, thank you to my parents Abe and Rae for a life-time of encouragement, support, patience and love, and for having made so much possible.

*R.H.*

I would like to thank my grandparents Ida and Leonard Mendelsohn for "field-testing" our interview questions. Thanks also to my brother Jeff for his unwavering support, love, and friendship. My parents Jay and Juel deserve a special thanks for their love, encouragement, and confidence in my abilities. Finally, my gratitude to Rob whose confidence, perseverance, and spirit have been an inspiration to me.

*L.J.*

The authors additionally would like to thank Laird and Glenn Towle and Karen Ackermann of Heritage Books for all of their efforts.

# 1 STORIES COME ALIVE...
# ...RIGHT ON YOUR TV!

## WHAT IS A VIDEO FAMILY PORTRAIT?

A VIDEO FAMILY PORTRAIT is a TV show *you* produce that stars *your* family -- parents, grandparents, brothers and sisters, children, and relatives.

> *IMAGINE ... seeing your grandmother smile as she talks about the children growing up! Or hearing your grandfather laugh as he recalls his favorite stories of the "good old days" ... RIGHT ON YOUR OWN TV!*

A VIDEO FAMILY PORTRAIT presents a life-like picture of your family that is more realistic than old photographs or home movies because it is *video*. It is a vivid documentary of what your family looks and sounds like. It is a family storybook narrated by the family members who remember important events which shaped their lives. But most important, it turns your TV into a family time machine, enabling you to share special feelings, thoughts, and memories with those you love, again and again.

## GOOD NEWS --
## YOU DON'T NEED A LOT OF FANCY EQUIPMENT!

Producing your own VIDEO FAMILY PORTRAIT does not require a lot of sophisticated equipment, connec-

tions, or operations.   As a matter of fact, all you really need is your camcorder, a video tape, a small tripod, and your own TV!   Or, if you don't have a camcorder, you can use *any* video camera and video cassette recorder.   (Throughout this book the term *camcorder* is used to denote all kinds of video cameras and video recorders.

Even if you have little or no video experience, this book will show you all the techniques you need to know to make terrific video recordings.   Video topics include how to properly

- set up and adjust your equipment
- compose an attractive television picture
- select complimentary camera shots
- and much more!

Confusing technical information has been reduced to a minimum and is presented in "user friendly" language. Special *HELPFUL HINTS* and *SAFETY TIPS* are noted wherever possible to make video taping easier to understand and to help you with explanations of recording procedures.   For those individuals who already have or would like to gain more video experience, there is a section covering advanced techniques.

## WHAT IS IT LIKE TO BE INTERVIEWED ON TV?

First of all, it is fun!   Everyone has a story to tell and most people like to talk about themselves. Telling stories often leads to wonderful memories which may not have been thought of in years.

During the VIDEO FAMILY PORTRAITS interview, individuals sometimes even forget they are being recorded and experience the many good feelings their memories bring.   As a matter of fact, people are so

pleasantly surprised and proud the first time they see themselves on TV, that they usually ask to see the entire tape replayed immediately after the interview is finished -- kind of like a "personal instant replay!" You can be sure that your VIDEO FAMILY PORTRAIT will be a TV show that remains popular throughout the years!

## OUR *FAMILY HISTORY QUESTION GUIDE* MAKES INTERVIEWING EASY!

VIDEO FAMILY PORTRAITS contains an exclusive *Family History Question Guide* which provides you with all the questions and guidance needed to make interviewing your subjects easy. The *Guide* will help you to conduct an informative, thoughtful, interview that will be enjoyable to all involved.

The *Family History Question Guide* is divided into nineteen categories of topics which include over three hundred possible questions you can ask family members. The *Guide* assists subjects in preparing for their interview and helps them to organize their thoughts and stories. Interviewers can also familiarize themselves with the questions in advance so that recording the interview can be an easier and more casual experience.

# 2 FAMILY INTERVIEWING "TIPS"

## HOW DO I APPROACH MY SUBJECTS ABOUT DOING AN INTERVIEW?

Sometimes the idea of doing an interview about one's own life conjures up images of preparing a last will and testament. For this reason, grandparents and other elderly family members may, at first, feel uneasy when you approach them about taping a VIDEO FAMILY PORTRAIT. If they are particularly old or frail, try to avoid making them feel that you fear they are about to pass away and want to tape them before it is too late.

Therefore, it is important to assure elderly relatives that you are genuinely interested in learning about their lives. Explain to them that you want to know more about their life experiences and memories. Try to encourage them to share their special stories with you and your family on video tape. Be patient if individuals seem to hesitate or resist, but try to continue your efforts until you have persuaded them to agree to a taping session. Your VIDEO FAMILY PORTRAITS tape is sure to become a family heirloom!

Be sure to tell each individual that they probably will not be able to share everything about their lives at a single interview session. Therefore, you would look forward to future interviews in which you can learn more about them. Remember, taping VIDEO FAMILY

PORTRAITS are not necessarily one-time events. They can continue to be done each year for years to come!

## WHEN IS THE BEST TIME TO DO AN INTERVIEW?

There is really no "best" time to do your VIDEO FAMILY PORTRAITS interview.   Any time your subject is willing, and you can get your equipment set up, is a good time.   Try to make plans in advance which are convenient for both the subject and yourself.   And don't forget, special family occasions and gatherings make particularly good times to record VIDEO FAMILY PORTRAITS!

## WHERE SHOULD I CONDUCT THE INTERVIEW?

Perhaps the most important consideration in conducting a VIDEO FAMILY PORTRAITS interview is to make your subject as comfortable as possible.   Try to seat your subject in a comfortable chair or couch in a room with a relaxed setting, such as a living room or den.

Avoid offices, kitchens, closed-in bedrooms, or any room with a cramped feeling.   Also, the room should not be too noisy or distracting.   Tidy up any un-necessary items or clutter before you begin the interview.

## WHO SHOULD BE PRESENT DURING AN INTERVIEW?

Some individuals love to tell their stories to a large family group and will not mind who is present during their interview.   Other individuals, however, have a

difficult time expressing themselves in front of others and tend to "clam up." It is therefore important to offer subjects the opportunity to have privacy during their interview, should they require it. In those cases, limit the number of individuals present during taping if it makes your subject more comfortable.

*SOME PEOPLE MAY "CLAM UP" IN FRONT OF OTHERS.*

## HOW MUCH DO I NEED TO PREPARE?

Preparation before an interview is always important, especially if you wish to make the most of your interview time. Reviewing the *Family History Question Guide* with the subject, as previously mentioned on page 13, will help the interviewer to better know and understand the individual being interviewed. The review will also help stimulate the subject's thoughts and memories, enable them to anticipate upcoming questions, and generally improve responses throughout the interview.

## WHERE SHOULD THE INTERVIEWER SIT?

The interviewer should sit just to the front of the tripod with his or her back to the camera, taking care not to block the subject from the TV picture. The subject can then face both the interviewer and the camera when responding to questions. This position also allows you the option to include the interviewer on camera. (see *Basic Camera Shots*)

The interviewer should neither slouch nor sit too stiffly in order to prevent the subject from feeling uncomfortable. Sitting naturally should help encourage your subject to do the same.

The interviewer should additionally try to maintain good eye contact with the subject, without looking like he or she is staring. Questions should be asked in a warm and expressive manner. Try to avoid a monotone sounding voice which might discourage subjects from getting excited about their own responses. Be tactful when dealing with sensitive or personal matters.

## HOW DO I GET THE INTERVIEW STARTED?

Before you get into the meat and potatoes of your VIDEO FAMILY PORTRAITS interview, it is helpful to get your subject to relax and to warm up to you. This is accomplished by first engaging the subject in some very basic and familiar conversation or small talk before you begin recording. We have included a sample warm up conversation in the *Family History Question Guide*. Also, check to see if your subject needs anything before you begin. It is thoughtful to have some water, coffee, tea, or a soft drink nearby for your subject's convenience.

Once recording begins, the interviewer should state the date, the place where the interview is taking place, the name of the person being interviewed, and the subject's family relationship. Then move on to the first question.

## HOW LONG SHOULD THE INTERVIEW LAST?

There is no set time as to how long to conduct your interview. The ability and willingness of your subject will most likely determine that. You should probably plan for each session to last about an hour, or an hour and a half at most.

If your subject is readily available and is willing, you can optionally plan to do interviews in smaller sessions over a longer period of time. In this manner, you can cover selected categories of questions in greater depth, rather than trying to do them all in one shot.

## WHAT IF THE SUBJECT'S RESPONSE DOES NOT COMPLETELY ANSWER A QUESTION OR NEEDS CLARIFICATION?

Sometimes just one question is not enough to get all of the information needed to cover a topic. Very often your subject's first response to a question will not provide you with the whole story. As an interviewer, you sometimes must be prepared to question your subject for additional information or clarification, such as by asking, *"What did you mean by that?"* Or you might have to give the subject a little encouragement to answer more by saying, *"Please continue"* or *"Can you elaborate or give me some more details?"*

## WHAT IF THE SUBJECT GETS EMOTIONAL DURING THE INTERVIEW?

Try to be sensitive to what is being said by your subject during the interview. Remember, they might be revealing very personal and perhaps unhappy thoughts which may not have been expressed for years. If a particular story or memory causes the subject to become choked up, or even to cry, pause a few moments to allow them to regain their composure before moving on to the next question.

## CAN WE TAKE BREAKS DURING THE INTERVIEW?

If the subject becomes fatigued, it is a good idea to take a short break before trying to continue. Allow the subject to get up and stretch, move around, get something to drink, go to the rest room, etc. until he or she feels comfortable enough to begin again. It is better to take several breaks and ask more questions later on than to get poor quality responses because a subject has become tired from the interview.

*HELPFUL HINT*
*Listen carefully, so that you can ask questions which will produce additional or clearer information from your subject. After asking a question, wait, and give the subject plenty of time to formulate an answer.*

*Be certain that you do not pose your questions in a threatening or challenging manner. Also, refrain from expressing your own personal feelings or opinions in a way which might be seen by your subject as confrontational. Try not to interrupt unless the subject gets way off track.*

## IS THERE ANY SPECIAL WAY TO END THE INTERVIEW?

After completing the interview, thank your subject and let him or her know how much you enjoyed the opportunity to talk. Before you stop recording, offer them a chance to comment on the interview session, mention any other final thoughts, or give any special words of greeting to their current or future family members.

# 3   "STAGING" YOUR FAMILY INTERVIEW

## CHOOSE A LOCATION

The room you select will become the "set" for your VIDEO FAMILY PORTRAIT. You may even consider rearranging some of the furniture, wall pictures, or decorations and adding plants or other decorative objects to the area. This will give your set added color and depth. Also, remember to remove unnecessary items which may clutter your picture.

## A BRIGHT ROOM IS IMPORTANT

Without enough light, your camcorder will provide a poor picture (flat colors, lack of detail, fuzzy images). A nice bright room, whether lighted by overhead lights, floor or table lamps, or windows, will provide a pleasant atmosphere and give your final tapes a clear and vivid look. In certain situations, additional television lighting may be required. (see section on *Advanced Techniques*)

## WHERE TO SIT

Try to select a location where your subject can sit comfortably throughout the duration of your taping session. If you will be displaying photos or memorabilia, make sure that these items are accessible

without being in the way when they are not being used. Also, be sure to leave enough room for other individuals to get in the picture if you plan to interview more than one subject at a time. If possible, try not to position subjects right up against a wall, since television already tends to "flatten" the appearance of the TV picture.

## BACKGROUND AND CLOTHING

Try to avoid very light or very dark backgrounds. Bright backgrounds tend to make the subject look too dark, while dark backgrounds may make the subject look too bright. Do not use windows or other brightly lit areas as a background and keep bright lamps and TV lights out of your picture.

Also avoid very busy backgrounds (flowered wallpaper, bookcases, stereo equipment, etc.) since they distract from your subject. In order to have individuals stand out from and not compete with the background, recommend that they wear bright, colorful clothing and, again, try to avoid very light or very dark colors if possible.

## SOUNDS AROUND THE HOUSE

Be aware of possible distracting sounds in the area where you are taping, such as telephones, home appliances, flushing toilets, street noise from open windows, and other individuals moving about the house. Take the phone off the hook, turn off TVs, dishwashers, etc., close windows, put the dog out, and try to limit general moving about in the area of your shoot. Remember, whatever your ears can hear will also be picked up on the tape!

## MAKE ROOM FOR YOUR VIDEO EQUIPMENT

Try to leave enough space to set up your camcorder at least five feet or so from your subject. This way the equipment will not seem too imposing or cause the subject to become "camera shy." A good camera position would be one in which you can get a *Full Shot* of the subject as well as zoom in for *Close Ups* of objects which are being discussed. (see section on *Basic Camera Shots*)

## IS THERE A PLUG NEARBY?

Make sure your location provides access to electrical outlets for any lights or equipment you will be using. Have extension cords handy so that you have the freedom to set up your equipment in the most convenient areas of the room. Use caution in laying cords across the floor in an area where someone might trip on them! Placing cords under a throw rug or taping them down with duct tape can help prevent possible accidents.

*TRY TO MAKE YOUR SUBJECT "STAND OUT"
FROM THE BACKGROUND!*

# 4   "USER FRIENDLY" VIDEO GUIDE

## YOU DON'T NEED A VIDEO DEGREE!

No one needs a degree in television production or broadcast engineering to produce their own VIDEO FAMILY PORTRAIT! The following guide will familiarize you with the basic terms and techniques of video taping in "user friendly" language and assist you in producing your interview. With these helpful hints and suggestions your VIDEO FAMILY PORTRAIT will be a success, look professional, and last for years to come!

> *HELPFUL HINT*
> *Not all camcorders have exactly the same adjustments and features. Consult your instruction manual for specific explanations of your camcorder's settings, functions, and operations.*

## *VHS, BETA, 8MM* -- WHAT'S THE DIFFERENCE?

If you have ever visited a consumer electronics store or have friends with video cassette recorders (VCRs), you probably know that there are different kinds of video tapes. Similarly, there are different kinds of video equipment on which to play these tapes. Although the video equipment itself appears pretty much the same, one kind of machine is not compatible with another. What that means is that whichever

equipment format you choose -- *VHS, Beta, or 8mm* -- your tapes can play only on machines using the same format.

By the same token, tapes recorded on a machine of another format will not play on your machine. Therefore, if you are purchasing or renting equipment for the first time, you may want to check with relatives who already own VCRs, just to know which format they are currently using. This can make exchanging tapes with them more convenient.

It is not necessary, however, to own exactly the same equipment since, although different formats are incompatible, all video tapes can be easily copied to a machine of a different format. This means that you will have no trouble sharing tapes with others. (Refer to section on *Advanced Techniques: Copying VHS to Beta or 8mm*).

### *8MM*

This is the smallest of the formats, which uses an 8mm-wide tape in a very small cassette. The small tape size has enabled manufacturers to produce the most compact and lightest weight camcorders to date. The *8MM* format also has an improved sound quality. Maximum *8MM* recording time is 120 minutes.

### *BETA*

This is the original home video recording format, which uses a 1/2" tape cassette. *Super Beta* camcorders are also available which offer very high picture quality. Some Beta machines offer professional editing features for the advanced video enthusiast. *Beta* camcorder maximum recording time is 200 minutes.

## VHS

This is the most widely used format, also on a 1/2" tape slightly larger than *Beta*. *"HQ"* models have an improved picture quality. *VHS* camcorder maximum recording time is 160 minutes.

## VHS-C

This is a format compatible with regular *VHS* which uses a 1/2" tape in a compact cassette. Again, the smaller cassette helps reduce the camcorder's size and weight. *VHS-C* camcorder maximum recording time is 60 minutes.

## YOU CAN USE ANY KIND OF EQUIPMENT!

No matter which you choose, camcorder or camera and VCR, either can be used to produce a VIDEO FAMILY PORTRAIT that your family will treasure for years to come. As a matter of fact, the newest video camcorders make the job easier than you ever imagined. Most camcorder models have made virtually all of the recording functions and adjustments totally automatic to simplify operation.

Even the features among the *VHS, Beta, and, 8MM* camcorders are pretty much identical. All of them will be satisfactory, no matter which you use. Of course, as with most consumer electronic products, the higher the cost, the more advanced are the features you get.

The best advise regarding the purchase of a new camcorder is to let a salesperson give you a demonstration of the latest models. Then you can compare features and performance and shop around for the one you like in your price range.

*HELPFUL HINT*
*If you don't already own a VCR, you might want*
*to consider purchasing a camcorder which, in*
*addition to recording, lets you play tapes on your*
*TV, directly from the camcorder.   Otherwise you*
*will need a VCR to watch your tapes.   This kind*
*of camcorder can also be useful for editing your*
*tapes.   (See section on Advanced Techniques:*
*Editing)*

## SOME IMPORTANT CAMERA SETTINGS

*IRIS*
An exposure setting which controls the amount of
light entering the camera through the lens.   Under
normal use, this should be set to *Auto*.

*HELPFUL HINT*
*To compensate for unusual lighting conditions,*
*such as when your subject is in bright light and*
*the background is dark, or vice versa, set the iris*
*to "Manual" and rotate the rear section of the*
*lens (marked in "f" stops) until the picture*
*improves.*

*GAIN (AGC)*
A picture adjustment which automatically increases
the camcorder's light sensitivity for use in low
lighting situations.   This setting is not recommended
unless normal picture quality is extremely poor due to
inadequate room light.

*FOCUS*
Rotating the front section of the lens in order to
sharpen the picture.   (Most camcorders have both an
*Auto-focus* and *Manual* switch.)   Your camcorder's
focus is preset at the factory, so when you use the

camcorder in the *Auto-focus* mode, it will continue to automatically focus the lens as you *Zoom In* and *Zoom Out* to different subjects.     (See *Basic Camera Movements*)

### HELPFUL HINTS
*If your focus is not sharp when you Zoom In...*

*1) Switch to "Manual" focus (if your camera has Auto-focus).*

*2) Zoom In all the way to your subject and focus the lens. The subject's hair or eyes are a good place to get a sharp picture.*

*3) Set the focus switch back to "Auto-focus." Your picture should now maintain proper focus when you Zoom In and Out to your subject.*

### WHITE BALANCE
Colors look somewhat different to a TV camera, depending upon the light in which you are shooting. This crucial adjustment makes sure that colors are not tinted because of different kinds of light.   For example, outdoors on a cloudy day, colors reflect more blue from the sky.   When in direct sunlight, colors reflect more yellow.   Indoors, colors reflect more red under incandescent lights and more green under fluorescent lights. Without proper white balance, your subject's skin tone will not look natural!

Many camcorders have an *Automatic White Balance (AWB)* setting to make this adjustment simple.   Others just have an *Indoor/Outdoor* switch.

### HELPFUL HINTS
*1) Have your subject hold a large piece of white paper (or other smooth white surface) in front of himself or herself.   Make sure the paper is in*

*the same light as the subject and that it doesn't have any shadows reflecting on it when you do your "White Balance".*

2) *"Zoom In" on the paper so that it fills up as much of your picture as possible.*

3) *Push the AWB switch to "Adjust". Usually you push this switch momentarily, then let go. Colors will now appear natural on television for your particular lighting situation. (Some camcorders have a "Continuous AWB" in which the camcorder measures the light and adjusts itself.)*

## BASIC CAMERA MOVEMENTS

*PAN*
Moving the camera from left to right, using the handle on your tripod.

*TILT*
Moving the camera up and down, using the handle on your tripod.

*ZOOM*
Bringing the picture in closer to the subject (*Zoom In*) or moving it away (*Zoom Out*) by rotating the mid-section of the lens. Zooming is usually done electronically by pushing the *Zoom Button* located near the lens or on the camcorder's handle.

The "*T*" on the Zoom Button stands for *telephoto*, which allows you to *Zoom In*. The "*W*" stands for *wide angle*, which allows you to *Zooms Out*. Some camcorders also allow you to vary the speed of your zoom lens by adjusting a *Slow/Fast* control.

*Zooming* can also be performed manually by switching from *Auto* to *Manual* and by rotating the *Zoom Bar* attached to the lens.

## RECOMMENDED CAMERA SHOTS

### COVER SHOT
Usually your widest shot (zoom all the way out), which gives the television viewer an overall look at the subject and the location of the taping.

### FULL SHOT
Shows the subject approximately from head to foot. (Depending upon how far your camcorder is from the subject, this shot might look the same as the *Cover Shot.*)

### MEDIUM SHOT
Shows the subject from approximately the waist to just above the head. This is a good shot to use if your subject uses his or her hands when talking.

### CHEST SHOT
Shows the subject from the chest to just above the head. This is a good shot to use throughout most of the interview.

### CLOSE UP
Shows the subject from the top of the shoulders to just above the top of the head. This is an excellent shot for capturing emotion and facial expressions, as well as providing the TV viewer with a feeling of intimacy with your subject.

*A "COVER SHOT" SHOWS THE ENTIRE
SUBJECT AND LOCATION OF THE INTERVIEW.*

*USE A "MEDIUM SHOT" WHEN THE
SUBJECT HOLDS UP PICTURES OR OBJECTS*

*A "CHEST SHOT" IS GOOD TO USE
THROUGHOUT MOST OF YOUR INTERVIEW.*

*USE A **"CLOSE UP"** TO CAPTURE FACIAL EXPRESSIONS AND EMOTIONS.*

*AN **"EXTREME CLOSE UP"** IS NOT ALWAYS FLATTERING TO YOUR SUBJECT!*

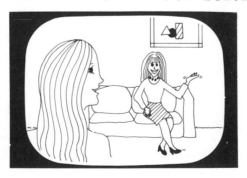

*AN **"OVER THE SHOULDER SHOT"** INCLUDES THE INTERVIEWER IN THE PICTURE.*

*EXTREME CLOSE UP*
Shows only the face of the subject. This shot may not always be very flattering to your subject and should be used sparingly, such as to accentuate extremely expressive or emotional moments.

*TWO SHOT*
Shows two individuals, evenly balanced, within the frame of your picture.

*OVER THE SHOULDER SHOT*
Used to include the interviewer in the shot. This shot gives the television viewer the feeling of being right there, asking the questions. The camera shoots the interviewer from close behind, showing his or her back, profile, and shoulder off to the side of the picture, while properly framing the subject on the other side of the picture.

## COMPOSING AN ATTRACTIVE PICTURE

*HEAD ROOM*
Make sure you leave some room at the top of the picture so that the subject's head is not cut off or right up against the top of the TV picture screen. The general rule is to keep the subject's eyes approximately one third of the way down from the top of the screen.

*NOSE ROOM*
When shooting the subject's profile, leave a little extra room in front of the face, in the direction the subject is looking.

## MORE THAN ONE SUBJECT

Television makes people seem further apart then they really are. Try to keep several subjects sitting as close together as is comfortable. Try to eliminate a large gap between subjects sitting in chairs, possibly by placing a house plant there.

## SUBJECTS WHO USE THEIR HANDS

If your subject uses his or her hands to enhance their conversation, make sure you zoom out occasionally in order to catch those motions and expressions.

## CENTERING

Center your subject in the middle of the picture except when including special objects being held by the subject or when showing decorative elements in your background. If you have more than one subject in your picture, frame your shot to evenly balance the two individuals on camera.

## CHOOSING A VIDEO TAPE

Video tapes come in several tape grades: regular grade, high grade, and extra-high or premium grade. The premium grade of tape costs about double that of the regular grade, but is well worth it for the purpose of recording a VIDEO FAMILY PORTRAIT. Premium tapes provide the best recorded picture and hold up better over time.

Since your VIDEO FAMILY PORTRAIT is not an experience which can be exactly repeated, it is additionally recommended that you use a brand new tape whenever shooting, to insure against potential problems which might arise from using slightly worn or damaged tapes.

## PREVENTING ACCIDENTAL ERASURE OF TAPES

After you have successfully completed your VIDEO FAMILY PORTRAIT, you will want to make sure that your work is not accidentally erased over. All video tapes are manufactured with a pop-out *Erase Tab* just for this purpose, located on the rear or the bottom of the tape's outer casing. Using a screwdriver or other flat instrument, gently pry out and remove the Erase Tab. Now, even if you inadvertently press *RECORD* instead of *PLAY*, no recording will actually take place.

> *HELPFUL HINT*
> *If you are not sure where the "Erase Tab" is on your particular tape, refer to the illustrations on the instructions or tape labels that are packaged with most new tapes.*

## TAPE HANDLING AND STORAGE

In order to insure that your tapes last a long time and provide you with the best viewing quality for years to come, it is important that you keep in mind the following considerations.

1.  Keep tapes away from:

    *PROLONGED EXPOSURE TO EXTREME HEAT--* such as near home heating vents, on appliances or equipment with warm surfaces, or in direct sunlight.

    *PROLONGED EXPOSURE TO EXTREME COLD--* such as in unheated attics and basements or overnight in a car during winter months.

*STRONG MAGNETIC FIELDS* -- which can occur near electrical equipment such as electric motors, televisions, stereos, and speakers.

*EXCESSIVE MOISTURE* -- avoid spilling anything on tapes or storing them in damp places.

*DUST* -- keep tapes in their original covers when not in use or purchase plastic tape boxes to insure maximum tape protection.

2. Do not leave a tape in your VCR when not in use.

3. Store tapes on their edges rather than flat, and preferably standing up. The recommended temperature range for storing tapes is 50 to 70 degrees.

4. Rewind tapes before storing for long periods of time, to keep even tension on tapes as they naturally expand and contract.

5. When playing or recording tapes, do not leave the machine in *PAUSE* unless necessary, or not more than a few minutes at a time if possible.

6. Avoid touching the actual tape with your fingers.

7. Never try to force any tape into your camcorder or VCR.

8. If you should drop your tape and break or damage the case, do not try to open or repair the tape yourself.

9. If your tape should break while in the machine, take your equipment to a qualified video technician to have the tape repaired and then duplicated onto a new tape. In case of other tape

damage, such as creasing or wrinkling, make a copy of the tape and do not play the damaged tape again since it can possibly damage your machine.

## CAMCORDER HANDLING AND STORAGE

Follow the same considerations for your camcorder as you would your video tapes, plus these additional tips.

1. Avoid excessive vibrations and jolts to the unit, such as in the trunk of a car and when the camcorder is not in its storage case.

2. Never point the camcorder directly into the sun or extremely bright lights.

3. Do not operate your camcorder near water or in the rain.

4. Avoid getting fingerprints or scratches on the surface of your camcorder's lens.

## CLEANING THE VIDEO HEADS

From time to time, the video heads in your camcorder and VCR can become dirty or clogged. If you hear the sound portion of your tape, but can see only "snow" or a partial, unclear picture on your TV, your video heads probably need cleaning.

To remedy this problem, there are several VCR head cleaning products on the market which can be purchased at video stores for under $10. Probably the most convenient cleaner is a special cassette tape which, when inserted into your machine and played, cleans the head until your picture clears up.

*HELPFUL HINTS*
*If you have no head cleaner on hand when your heads clog try this ... continue to PLAY (or FAST SEARCH) your tape for several minutes. Sometimes the clog will clear itself up.*

*If your video heads seem to clog frequently, it might be that you are using a damaged, old, or poor quality tape. Try another tape or tape brand and see if the situation improves.*

## CLEANING YOUR CAMCORDER LENS

Before you begin taping, wipe your camcorder lens with some lens tissue to make sure you have a clear picture. You can use either lens tissue for eyeglasses or the photographic kind. Regular tissues can work if you have no other choice, but they might still leave some dust behind. Remember to rub gently!

To remove stubborn fingerprints, use a photographic lens cleaner, which can be purchased from most photo dealers. Do not use any other kind of cleaners, since they might damage the surface of the lens.

# 5 GET YOUR EQUIPMENT "SET UP"

## START WITH YOUR TRIPOD

Extend the legs of the tripod so that when your camcorder is mounted, the lens is slightly higher than the eye level of your subject. You can also raise the center pole of the tripod (if your tripod has one) to get the camera to the desired height.

Before mounting your camcorder, locate the tripod's *TILT LOCK* (see tripod instructions) and make sure it is tightened. You only need to make it "finger tight." This safety measure will prevent your camcorder from inadvertently flipping upward or downward when not in use.

## MOUNT YOUR CAMCORDER

*Carefully* mount your camcorder on the tripod using the *mounting screw* on the top of the tripod. There are usually several size holes on the bottom of the camcorder, and one will fit your tripod's mounting screw.

### SAFETY TIPS
*1) Remember to loosen the TILT LOCK when actually operating the camcorder or you will strip the treads and damage your tripod.*

*2) Always tighten the TILT LOCK when leaving your camcorder unattended on the tripod.*

## MAKE THE PROPER ADJUSTMENTS

*STEP 1*

Make sure you have a fully-charged battery in your camcorder, or, connect the camcorder to its *AC Power Adapter*. (This accessory lets you plug your camcorder into a wall outlet.)

### HELPFUL HINT
*Batteries are not recommended for extended shooting, such as over an hour, unless you are certain they are fully charged and can last about two hours. Dead batteries will cause the tape to stop in the middle of your interview. Consult your camcorder owner's manual for exact power connections and operating instructions.*

*STEP 2*

Insert your video tape.

*STEP 3*

Set *Indoor/Outdoor* lighting switch to proper position (where applicable).

*STEP 4*

Make sure the *Iris* (or *Exposure*) setting is set to automatic.

*STEP 5*

Remove the lens cap and turn on the camcorder.

*STEP 6*

When you have a picture, *Zoom In* all the way on your subject to make sure he or she is in focus.

*STEP 7*

Reset *Focus* if necessary. (see section on *Basic Camera Movements*)

*STEP 8*

*Zoom Out* all the way. The picture should now be in focus for both *Close-Ups* and *Wide Shots*.

*STEP 9*

Set *White Balance*. (refer to section on *Basic Camera Adjustments*)

*STEP 10*

Do a test recording and play it back to make sure everything is working!

# 6    LIGHTS, CAMERA, ACTION!

## GET YOUR RECORDING STARTED

Give your subject and interviewer about ten seconds advance notice before you begin recording, so that they may prepare themselves to speak. You should actually begin recording about five seconds before you have the interviewer ask the first question. This gives the camcorder the necessary time to begin recording a completely smooth picture and makes sure that the first words spoken are not accidentally cut off.

If your camcorder is equipped with a *Fade In* button, push it before you begin recording (consult your camcorder owner's manual).

Begin your VIDEO FAMILY PORTRAIT with a *Cover Shot* or *Wide Shot* in order to help familiarize the television viewer with the surroundings.

After the introductory remarks are complete, slowly zoom in to a *Medium* or *Chest Shot* of your subject. In order to keep viewer interest throughout the interview, you will need to vary your shots from time to time, especially when lengthy answers are given. Remember, continuous use of the same shot will make your tape seem dull and monotonous.

While you are recording, make sure you pay attention to what the subject is saying. You should anticipate the subject's moves (such as bending over to pick up an object), so that you may react accordingly by changing your camera shot. After recording the interview for several minutes on the same shot (let's say it is a *Chest Shot*) you could:

1) Slowly *Zoom In* for a *Close Up*, especially if the subject is giving a lengthy answer.

2) During the interviewer's next question, slowly *Zoom Out* to a *Medium Shot* or a *Full Shot*.

3) After the question has been asked, stay on the same shot if the subject's answer appears to be a short one, then slowly *Zoom In* to a *Chest Shot* or *Close Up* during a lengthy answer.

4) Be prepared to *Zoom Out* to a *Wide Shot* when the subject picks up an object to show (or if another individual enters the picture to sit beside the subject).

5) After the object has been picked up, *Zoom In* for a *Close Up* while it is being discussed. Hold that shot long enough for the viewer to get a good look at the object, then slowly *Zoom Out* to a *Medium* or *Wide Shot* to show both the object and the subject together.

*HELPFUL HINT*
*Decide which way you want to move the camera before you begin changing your shot. Any indecisiveness in selecting a shot may result in jerky camera movements, which will be disturbing to the television viewer. It is better to stay longer on the same shot, than to keep moving the camera around while you try to decide on your*

*next shot. Remember, camera movements should enhance the interview, not distract from it!*

## VIEWING TV WHILE YOU TAPE

If your camcorder provides you with this option, you may hook the camcorder directly to a TV set. You will then see exactly how your picture looks in color on a full size TV set. This way you can make any necessary adjustments to your setting, lighting, or camcorder before you actually begin recording.

The TV will also give other family members an opportunity to see what is being recorded on tape throughout the interview. It is not recommended, however, that the TV set face the person being interviewed. This will distract them from the questioning and make them pay more attention to what they look like on TV. Also, do not turn up the volume on the TV or you will cause *feedback*, an annoying high-pitched sound.

## TAKING RECORDING BREAKS

Taping your VIDEO FAMILY PORTRAIT does not have to be done in one continuous, lengthy session. (see section on *Family Interviewing Tips* regarding how to take a break during the interview.) However, the length of time you choose to take for an interview break will determine what you should do with your camcorder during the break. Before taking a break, you have two recording options:

1) *"STOP" The Recording*
   If the interview break will be longer than five minutes, push the *STOP* button. This halts the recording process by shutting off the video signal and disengaging the tape.

To resume recording, press the *PLAY* and *RE-CORD* buttons about five seconds before you give the interviewer the cue to begin.

*HELPFUL HINT*
*When you play your tape on TV, you will notice a "glitch" (a momentary change in the color and/or stability in the TV picture) at the point you stopped and restarted your recording. This is a normal occurrence caused by interrupting the camcorder's recording mode.*

2) *"PAUSE" The Recording*
If your break will be less than five minutes, you can push the *PAUSE* button to pause, instead of stop, the recording process.

To resume recording, press the *PAUSE* button again about five seconds before giving the interviewer the cue to begin.

*HELPFUL HINT*
*In this case, the video signal is not shut off, as when the STOP button is pushed. Now when you play your tape on TV, the result will be a "glitch-free" picture. Should you happen to leave your camcorder in PAUSE for more than five minutes, it will automatically return to STOP and disengage the tape as a safety feature to prevent accidental damage to either the tape or the video record heads. If this should occur, proceed as if you had pushed STOP.*

## ENDING YOUR RECORDING SESSION

When the interview has concluded and you are ready to finish your recording session:

1) *PAUSE* the tape and put the lens cap back on.

2) Push *PAUSE* again, let the tape record for about ten more seconds, then push *STOP*. This will give you a nicer, "finished-looking" ending, rather than a "snowy", noisy picture which normally occurs at the end of the tape. (If your camcorder is equipped with a *FADE* button, you can push *STOP* (consult your instruction manual).

3) Tighten the tripod *TILT LOCK*.

4) If you have used TV lights turn them off and let them cool before putting them away. (See section on *Advanced Video Techniques: Adding TV Lights*)

5) Rewind, remove, and label the tape. Put it back in its box after viewing it.

6) Turn off your camcorder.

### SAFETY TIP

*KEEP YOUR CAMCORDER AWAY FROM EXCESSIVE MOISTURE!*

# 7 "ADVANCED" VIDEO TECHNIQUES

As good as the new camcorders are in producing pictures and sound for television, they are, nonetheless, limited under certain conditions. Here are some additional techniques and optional equipment you can use to expand your production capability and improve the quality of your VIDEO FAMILY PORTRAIT.

## IMPROVING YOUR SOUND

One of the more limiting features of a camcorder, when recording a VIDEO FAMILY PORTRAIT, is the camcorder's *built-in microphone*. In short, the further you place a microphone from your subject, the more "hollow" his or her voice will sound. Since you don't want to put your camcorder too close to your subject's face, microphone ends up several feet away from them.

Although the camcorder's built-in mike produces an acceptable recording, use of an optional mike will dramatically improve the voice quality of your VIDEO FAMILY PORTRAIT. Your best choices are either a *hand-held* mike or a *lavalier* mike. The hand-held mike is fairly inexpensive (under $20) and can be placed on a table or chair close to your subject. The lavalier mike is a tiny mike which can be clipped right onto the subject's shirt or dress (under $100 for an inexpensive model).

In order to plug an optional mike into your camcorder, the mike cable must have a *mini-jack* connector on the end which plugs into the camcorder. If your mike happens to have a different connector, you can purchase an adaptor plug for it (under $5). It is also helpful to have at least a ten foot mike cable which will enable you to easily reach your subject regardless of where you place your camcorder. Microphone extension cords can also be purchased for under $5. Consult your audio equipment dealer to choose what is best for your needs.

## ADDING TV LIGHTS

Less than ten years ago the saying about video was, "The more light, the better." Today's camcorders, however, can produce a surprisingly good picture with relatively little light.

A bright, evenly lit room, however, is still best for producing your VIDEO FAMILY PORTRAIT. If your location does not have enough available room light or is unevenly lit, you can add some TV lights. (Light sources producing uneven lighting may be large picture windows, bright lamps in corners, and reflective surfaces such as glass picture frames.) Even a room which is evenly lighted, such as by overhead fluorescent lights, may still require additional lights to help improve the video picture quality.

The basic problem of typical house lighting is that overhead lights do not throw light directly on the subject's face. In poorly lit areas, adding some direct light will improve the video picture color and quality. Overall, direct light is more complimentary to your subject than is overhead light.

A fairly simple solution to a poorly lighted room is to get a simple *clip-on reflector lamp* (available from

most hardware stores for under $10) and a 250 watt photo-flood bulb (available at most photo stores for under $5). Ask for a bulb whose *color temperature* is balanced for TV, not photography (the proper one is designated 3200K). If you have no other choice, a standard incandescent light bulb will do, although the colors on TV may appear slightly reddish.

### *HELPFUL HINTS*

*1) Make sure you "White Balance" your camcorder under the final lighting conditions. (see section on "Important Camera Adjustments")*

*2) Try to use the "reflector" type of lamp rather than a direct "spot" light, since the reflector throws a soft, diffused light and produces fewer shadows behind your subject.*

*3) It is advisable to place lights about ten feet away from and a little off to the side of your subject, so that your subject does not have to look directly into them. Remember, try to make your subject as comfortable as possible!*

*4) Try to avoid mixing different kinds of light (such as light from an open window and light from a lamp), since this might cause the subject's facial color to look unnatural.*

*5) If the addition of a light causes a very bright, or "hot spot" in your picture, you can point the light away from the subject. (Try to reflect the light off the ceiling or a nearby wall to soften the effect.)*

## EDITING TAPES

You may wish to edit your VIDEO FAMILY PORTRAIT tapes, whether to condense information, remove errors

and long pauses, or to combine different recording sessions onto a single tape.

To edit your tapes, you will need two VCRs. The "Play" machine will be used to play your original tape. The "Record" machine will be used to make your edited tape. You will also need a TV set to view your edits. Some camcorders can function the same as a VCR, enabling you to play your original tape on your camcorder and use your VCR for editing. (consult your camcorder owner's manual). Otherwise, check with your local video store for VCR rental prices if you will need to obtain an additional machine.

### How To Connect The Machines

1. Place the "Play" and "Record" machines side by side, to simplify connections and editing.

2. Connect *AUDIO OUT* and *VIDEO OUT* on the "Play" machine to the *AUDIO IN* and *VIDEO IN* of your "Record" machine, using a standard "phono cable" (the same kind you use to hook-up your turntable or cassette player to your stereo).

3. Connect the "Record" machine's *ANTENNA OUT* (or *RF OUT*) to your TV, using a standard (*coaxial*) video cable. This will enable you to see what the "Play" machine is playing and what the "Record" machine is actually recording. If your TV does not accept a coaxial video cable, you will need a *cable adaptor* (available wherever TVs are sold) which connects the video cable to your TV's antenna screws.

4. Make sure all cables have a tight connection.

*HELPFUL HINT*
*Do not stack your machines on top of your TV or each other. Your recorded picture could experience interference if both machines play and record too near each other.*

## How To Edit

1. Put your original tape in the "Play" machine and a new blank tape in the "Record" machine. (It is a good idea to do a test edit to make sure everything is working properly.)

2. *PLAY, FAST FORWARD*, or *REWIND* your original tape on the "Play" machine until you get to about ten seconds before the actual starting point of the segment you want to edit, then push *PAUSE*. (This ten-second "lead time" will help you make a more accurate edit.)

3. On your "Record" machine push *PLAY* and *RECORD*, then *PAUSE*. Both machines are now ready to perform the edit.

4. Push the *PLAY* button on the "Play" machine to allow the tape to begin playing your segment.

5. Just before the "Play" machine gets to the beginning of the segment, press the *RECORD* button on the "Record" machine to begin editing. You are now copying the selected segment on your "original tape" onto the "edit tape."

6. When the segment has concluded, push the *PAUSE* button on the "Record" machine to complete the edit.

7. *FAST FORWARD* or *REWIND* the tape on the "Play" machine until you reach the next segment

you wish to edit.   Then repeat the previous steps.   In this manner you will "assemble" segments, one after another, from your "original tape" onto your "edit tape."

8. When you are finished editing, push *STOP* on both machines and rewind your tapes.

*HELPFUL HINTS*
*On some machines you need to push the PAUSE button again to allow the machine to play or record.   If you are not sure how your camcorder or VCR works, consult the owners manual.*

*In order to prevent a "glitch" (the picture momentarily jumping or breaking up at the points where you make your edits), make sure you press PAUSE, not STOP, on your "Record" machine. (See section on "Taking Recording Breaks" for further explanation.)*

## MAKING COPIES OF YOUR TAPES

It is easy to make copies of your VIDEO FAMILY PORTRAITS tapes, or even of your edited tapes, to send to relatives, to give as gifts, or to keep as back-ups in case the original tape gets lost or damaged.

To make a copy of your tape, follow the procedure described in *the section on Editing Tapes* for connecting your machines.   At the beginning of your *original tape*, push the *PLAY* button on the "Play" machine at the same time you push the *PLAY* and *RECORD* buttons on your "Record" machine.   When the copying is completed, push *STOP* on both machines and rewind your tapes.

*HELPFUL HINT*
*In video, the picture quality on a copy is never as good as on the original. However, the difference is usually negligible to the untrained eye. It is recommended that you always use premium tapes when recording or editing your VIDEO FAMILY PORTRAIT. Remember, the better the recording quality on your original, the better the copy!*

## COPYING *VHS* TAPES TO *BETA* OR *8MM*

It is possible that you will want to send a copy of your VIDEO FAMILY PORTRAIT to some one whose VCR is a different tape format than yours. (For example, yours is *VHS* and they have *Beta* or *8MM*). As you know, your tape cannot be played on their VCR.

This is not a problem, however, since you can connect your VCR to a different format VCR to make a copy. Follow the same procedure as described in the section on *Making Copies Of Your Tapes*. Again, consult your local video store for rental prices of the VCR you need to rent if necessary.

## TRANSFERRING OLD HOME MOVIES TO VIDEO

All those old *Regular 8mm* and *Super 8mm* home movies which have been collecting dust in the closet can also be converted to video these days! Not only is this a good idea in order to preserve the movie images before they fade away or before the film deteriorates, but it makes viewing films a lot more convenient. No longer will you have to go through the trouble of setting up a projector and screen. Plus, you can get two or more hours of home movies onto a single video tape!

## The "Do-It-Yourself" Method

Probably the simplest way to transfer movies to tape is to project your movies onto a screen or white wall. Place the projector close to the screen or wall (about two to three feet away). This produces a small picture which provides a brighter and sharper image than does a large projected picture.

Set up your camcorder on a tripod behind the projector, then *Zoom In* on the picture until it fills your camcorder's picture screen. Record as you would normally and push *PAUSE* at the end of each roll of film until you start the next one.

Several inexpensive film-to-video conversion kits are also available which help to make the job more convenient. Check with your local video dealer for more information.

### *HELPFUL HINTS*

*1. You can leave the lights on in the room while recording movies. Don't worry that you can't see the movies as well as you would normally expect to. The TV camera will see it just fine and the added light actually helps the recorded TV picture look better than it would in the dark.*

*2. Before you begin recording, "White Balance" your camcorder on the light projected on the screen or wall. (See section on "Some Important Camera Settings")*

*3. Because of a basic difference between movies and video, you may notice a "flutter" around the edges of your movies when viewing them on TV. This flutter can be more pronounced in Super 8 than in Regular 8.*

4. *Also, because of a slight difference in the picture shape between video and film, a small portion of the movie image will be cut off in order to completely fill the camcorder's picture screen.*

## The "Professional" Option

In order to completely eliminate flutter, a special projector is required to make film compatible with video. If you find the flutter too distracting or you just do not have the time and inclination to make copies yourself, you can have your home movies transferred professionally to video tape. Many photo and video stores now offer this service at a cost of about $3-$6 per roll of film. If you can afford this method, you will appreciate the quality and the convenience.

> ### HELPFUL HINT
> *After your movies have been transferred to tape, you have the additional option of editing them or combining them with your VIDEO FAMILY PORTRAITS tapes. Just follow the previously described editing suggestions.*

## Adding Sound To Silent Movies -- A Whole New Way!

Unfortunately, most old home movies do not have any sound. However, here is a special way to add sound to your movie tape that will provide both an informative as well as entertaining dimension to your home movies.

Plan to bring all your family members together to watch the tape of your home movies. Before you begin showing the tape, connect a microphone to your VCR and place the mike near the center of where

everyone is seated. Encourage your family to ask questions and talk about the people they see while they watch the tape.

Now, instead of just playing your tape, you can do an *AUDIO DUB*. This is a feature of your VCR which will allow you to record everyone's reactions right onto the tape while you watch it! The original picture (in this case your old home movies) is not affected at all during an *AUDIO DUB*. Only the sound is recorded. (Consult your VCR owner's manual for specific recording instructions).

Now when you watch your previously "silent movies" on your TV, they will contain a "sound track" of stories, laughter, and many surprise reactions. It's a whole new way to look at old home movies while learning about and sharing in family history!

## *SAFETY TIP*

*KEEP YOUR TAPES AWAY FROM EXCESSIVE HEAT!*

# 8   VIDEO TAPING
# "SPECIAL OCCASIONS"

## HOW TO SHOOT A WEDDING

### The Ceremony

Ideally, it is desirable to record the wedding couple's faces as they recite their vows.  If possible, set up your camcorder on a tripod in front of and off to the side of the wedding party, facing the bride and groom.  This position will also enable you to capture the bridesmaids and ushers, family, and bride and groom as they enter the room and walk down the aisle.

Additionally, you can get a nice shot of the couple and the individual conducting the ceremony.  As the couple recites their individual vows use a *Two Shot*, zoom in for a *Close Up* when they exchange rings, and for an *Extreme Close Up* to capture the kiss!

If you cannot position the camera where you can see the couple's faces, some alternative spots are:  in the seating area several rows back and toward the center of the room; in the aisle in back of the room; or in a balcony.  Although you will not see their faces, you can still get occasional profiles of the couple and the face of the individual conducting the ceremony.  In this position, you can also zoom all the way out to include the whole wedding party.

Plan to record the entire ceremony, starting with the wedding party's entrance down the aisle, through the vows, and until they have exited the room.

### *After The Ceremony*

Next, push the *PAUSE* button, take the camcorder off the tripod, and use it *portable fashion* on your shoulder. Resume recording by following the interaction in the wedding party's receiving line. Don't be afraid to get up close to the bride and groom as they are being congratulated. Show them shaking hands (*Wide Shot*), get a *Close Up* of kisses, and maybe use an *Extreme Close Up* to capture smiles or tears of joy (or relief). Then get similar shots of the families, ushers, and bridesmaids in the receiving line. If rice is going to be thrown, you might want to get positioned outside before the bride and groom exit.

### *HELPFUL HINTS*
*1) Remember, the further away you are from the person speaking, the less voice and the more background noise your microphone will pick up. If you can conveniently place an optional microphone near the participants without interfering with the ceremony, it will greatly improve your sound. (Refer to the section on "Improving Your Sound")*

*2) If you run the mike cable along the floor where people will be walking, make sure you tape it down with duct tape to prevent people from tripping over it.*

*3) Always check with the individual conducting the ceremony beforehand for permission to record and to set up your equipment in your preferred position.*

*4)  Don't forget that if you go outside to tape, you will have to change the "Indoor/Outdoor" settings on your camcorder and do another "White Balance".*

## Add A Special Touch With "Video Snapshots"

A favorite technique, which really captures the flavor and personality of any special family event, is to take *Video Snapshots* of all the friends and relatives sharing special times with you and your family. Go around and interview the people who are in attendance and ask them to comment on the event or say a few words on camera.

At a wedding, ask people to express their congratulations, a personal message, or some "words of wisdom" to the bride and groom. Not only is this a great way to record everyone who was with you, it makes for a lot of fun listening to all the comments when you play back your tape!

## The Reception

After interviewing a dozen or so individuals, record some of the other action going on at the reception. Some of these activities include: the food being served; toasts to the bride and groom; introductions of family; special dances; cutting of the cake; throwing of the bouquet and garter; and any other joyous celebrating.

You might record some activity for several minutes and then follow it with more interviews of people, followed by another activity, and so on. A nice touch, when you are ready to end the tape, is to have the bride and groom record their own final impres-

sions of the day and to give their own personal messages for posterity.

### HELPFUL HINTS

*1) When using your camcorder on your shoulder and moving around to follow the action, try to select the shot you want to show and use all of the previously discussed techniques for composing an attractive picture.*

*2) Do not ZOOM In and Zoom Out or PAN left and right too quickly or too often. Remember, allow time for the television viewer to watch what's going on and get involved in the action.*

## NOW YOU CAN TRANSFORM YOUR TV INTO A FAMILY TIME MACHINE!

Use the *Video Snapshot* approach to document all special family occasions and to capture those special individuals who share precious moments with you. You are limited only by your imagination. Be creative! Here are just a few more suggestions of opportunities to make *Video Snapshots*.

| | |
|---|---|
| *VACATIONS* | *PARTIES* |
| *CHILDBIRTH* | *BIRTHDAYS* |
| *GRADUATIONS* | *TESTIMONIALS* |
| *ANNIVERSARIES* | *CONFIRMATIONS* |
| *FAMILY REUNIONS* | *OFFICE PARTIES* |
| *AWARD CEREMONIES* | *HOLIDAY MESSAGES* |
| *BAR & BAS MITZVAHS* | *AND MUCH MORE!* |

# 9 FAMILY HISTORY QUESTION GUIDE

## HOW TO USE THE
### *FAMILY HISTORY QUESTION GUIDE*

Prior to taping, the person who will be the inter-
viewer should review all of the categories and
questions on the *Family History Question Guide* with
the family member who will be interviewed. The
interviewer and subject should then work together in
deciding which questions will be asked during the
actual interview.

Those questions which pertain to the subject's
experiences and background or those which prompt a
special story or memory should be marked with an
"X". In this manner, both the subject and interviewer
will know what to expect during questioning and will
be better prepared for a thoughtful and informative
interview.

### *HELPFUL HINT*
*Remember, these are only recommended questions
to help the interviewer guide subjects through
their VIDEO FAMILY PORTRAIT. Questions
which are considered too personal or do not
pertain to the individual being interviewed can be
ignored. We also encourage you to alter the
questions or list additional ones that will help
your subject to more effectively tell his or her
unique story.*

The *Family History Interview Guide* should also be used as an actual interview work sheet. The interviewer can jot down notes beforehand or add follow-up questions during the interview in case the subject reveals something unexpected. Blank lines have been provided in each of the interview categories to write in additional questions. Try to keep note-taking to a minimum during the interview since it can be distracting to the subject.

Two identical *Family History Question Guides* have been included in this book to allow you to make separate notes for each VIDEO FAMILY PORTRAIT interview you conduct.

VIDEO FAMILY PORTRAITS
# FAMILY INTERVIEW #1

SUBJECT'S NAME

INTERVIEWER'S NAME

DATE(S) OF INTERVIEW

PLACE OF INTERVIEW

## LET'S ASK SOME QUESTIONS!

### *HELPFUL HINT*
*Review the Family Interview Guide with the subject and mark those questions which you will discuss during the interview with an "X". Make any changes or additions which are appropriate. YOU DO NOT HAVE TO ANSWER EVERY QUESTION.*

## SAMPLE WARM-UP CONVERSATION

(Make a test video recording during the warm up.)

*Hello. You are looking nice for your recording.*

*We are about to begin the interview session which will cover the questions we discussed and selected beforehand.*

*Is that agreeable to you? Are you comfortable? Is there anything I can get you?*

(Stop the test recording)

*Now we will playback the tape just to make sure that everything is working properly.*

(Make a final tape check.)

*Everything looks fine. If you are ready, let's begin.*

(Make sure tape is recording)

## INTRODUCTION

[ ]   *Today is:* (day, month, date, year)

[ ]   *We are at:* (place of interview)

[ ]   *My name is:* (name of interviewer)

[ ]   *We are about to make a VIDEO FAMILY POR-TRAIT.*

### Let's Introduce Our Special Guest

[ ]   What is your full name.

[ ]   In what year were you born?

[ ]   Where were you born?

[ ]   How old are you now?

[ ]   Where do you currently live?

*(Additional Questions)*

[ ]   _____

[ ]   _____

### Let's Talk About Your FAMILY ROOTS

[ ]   What country(s) and city(s) did your ancestors come from prior to settling in the United States?

[ ] What can you tell us about the lives of these people before they arrived in this country?

[ ] What were their occupations?

[ ] What brought them to this country?

[ ] How did they get here?

[ ] Do you know in what year they settled?

[ ] Where did they settle?

[ ] Can you tell us why they chose to settle there?

[ ] What were the names of each of the individuals who first came to this country?

[ ] What were their relationships to each other?

[ ] What do you know about any of their other relatives?

[ ] Can you describe any of their extended family, such as aunts, uncles, or cousins?

[ ] How did their lives change after they arrived:

[ ]     economically?

[ ]     socially?

[ ]     politically?

[ ]     religiously?

[ ]     occupationally?

[ ]     family-wise?

[ ]   How many generations of your family have lived in this country?

[ ]   Do you have any special stories or recollections that you would like to share about your ancestors?

*(Additional Questions)*

[ ]   _____

[ ]   _____

### *Let's Talk About Your PARENTS*

[ ]   What is your father's full name?

[ ]   When was he born?  Where?

[ ]   When did he die?  Where?

[ ]   How old was he when he died?

[ ]   What did he look like in your earliest memories?   (height, weight, hair color, eyes, complexion, etc.)

[ ]      in your teenage years?

[ ]      in your adult years?

[ ]   What can you tell us about his current or last occupation?

[ ]   Where and when did he pursue his occupation?

[ ]     Did he ever change occupations?

[ ]     Can you tell us about them?

[ ]     What is your mother's name and maiden name?

[ ]     When was she born? Where?

[ ]     When did she die? Where?

[ ]     How old was she when she died?

[ ]     What did she look like in your earliest memories? (height, weight, hair color, eyes, complexion, etc.)

[ ]        in your teenage years?

[ ]        in your adult years?

[ ]     What can you tell us about her current or last occupation?

[ ]     Where and when did she pursue her occupation?

[ ]     Did she ever change occupations?

[ ]     Can you tell us about them?

[ ]     How, where, and when did your parents meet?

[ ]     At what age were they married and where?

[ ]     Was it the first marriage for each?

[ ]     If not, can you tell us about his or her previous ones?

[ ]   When did they have their first child?

[ ]   How many children did they have all together?

[ ]   What were your parents' feelings regarding discipline?

[ ]   How did your parents influence you concerning:

[ ]       religion?

[ ]       money?

[ ]       education?

[ ]       social values/morals?

[ ]       relating to other people?

[ ]       children?

[ ]       work?

[ ]       politics?

[ ]       marriage?

[ ]   What were some of your parents' hobbies or leisure activities?

[ ]   What can you tell us about some of your parents' special friends?

[ ]   Do you have any special stories or recollections about your parents that you would like to share?

*(Additional Questions)*

[ ]  _____

[ ]  _____

## Let's Talk About Your CHILDHOOD

[ ]  Did you grow up primarily in one area?

[ ]  Did you move around a lot growing up?

[ ]  Did you like it and how did it affect your childhood?

[ ]  What was it like where you grew up?

[ ]  Were you:

[ ]  happy as a child?

[ ]  more introverted or extroverted?

[ ]  obedient or disobedient to your parents or authority?

[ ]  popular with other children?

[ ]  Who were some of your special friends?

[ ]  What can you tell us about your interests or activities?

[ ]  Did you ever have any health problems?

[ ]   Tell us about any childhood special achievements, accomplishments, or recognition.

[ ]   Who were your childhood role models or heroes?

[ ]   Why did you identify with them?

[ ]   Did you ever run away from home?

[ ]   What happened?

[ ]   Did your parents ever punish you?  How?

[ ]   Is there any particular childhood experience that dramatically changed your life?

[ ]   What was dating like when you were a young adult?

[ ]   When was the first time you fell in love?

[ ]   Can you tell us about it?

[ ]   What was your most memorable childhood experience?

[ ]   What was your most frustrating childhood experience?

[ ]   What was your most embarrassing childhood experience?

[ ]   What did you want to be when you grew up?

[ ]   Did you have any special travel experiences?

[ ]   What was your fondest possession?

[ ]   What did you always want that you never had?

[ ]    Who was the nicest person you ever knew?

[ ]    Who was the meanest person you ever knew?

[ ]    What are your fondest childhood memories?

*(Additional Questions)*

[ ]    _____

[ ]    _____

## Let's Talk About Your CHILDREN

[ ]    What are the full names of your children?

[ ]    When was each born?  Where?

[ ]    What are their current ages?

[ ]    Describe your memories during pregnancy and/or childbirth.

[ ]    Were all of your children planned?

[ ]    Did you lose any children?

[ ]    What happened?

[ ]    Did you find raising your children to be a difficult or easy task?

[ ]    What made it so?

[ ] Did you have any extra help in raising your children?

[ ] What were your most trying moments as a parent?

[ ] What was your worst experience in raising a child?

[ ] What was the funniest experience?

[ ] What was the most rewarding experience?

[ ] How did you discipline your children?

[ ] How did children affect and/or change your:

[ ]     work?

[ ]     relationship with your spouse?

[ ]     relationship with your parents?

[ ]     outlook on life?

[ ] Did you take family trips with the children?

[ ]     where and when?

[ ]     which was the most memorable?

[ ] Did your children ever have any serious health problems? Please describe.

[ ] Who was most responsible for disciplining your children?

[ ] What did you think your children would become when they grew up?

[ ] Did your children spend much time with any particular relatives?

[ ] What are your fondest memories regarding your children?

[ ] What makes you proudest about being a parent?

[ ] Do you have any special thoughts you would like your children to remember about themselves?

*(Additional Questions)*

[ ] _____

[ ] _____

## Let's Talk About Being GRANDPARENTS

[ ] When did you first become a grandparent?

[ ] How did it make you feel?

[ ] How old were you at the time?

[ ] How many grandchildren do you now have?

[ ] What are their names?

[ ] What is best about being a grandparent?

[ ] Do you have any great-grandchildren?

[ ]   What are their names?

[ ]   What can you tell us about being a great-grandparent?

[ ]   Do you have any special stories about your grandchildren that you would like to share?

*(Additional Questions)*

[ ]   _____

[ ]   _____

## *Let's Talk About Your EDUCATION*

[ ]   What was the name and location of your:

[ ]       grammar school?

[ ]       junior & senior high?

[ ]       college or university?

[ ]       post-graduate school?

[ ]       other schools? (vocational, special training)

[ ]   What was your grade school like?

[ ]   How did you get to school everyday?

[ ]   What were your favorite grade school subjects?

[ ]   What kind of student were you?

[ ] Did your parents help you with your school work?

[ ] Did you have any particularly influential or favorite teachers?

[ ] Who were your best school friends?

[ ] What are your best school memories?

[ ] Did you ever "play hooky" from school?

[ ] What did you do instead of going to school?

[ ] Did you ever get caught? What happened?

[ ] What was your worst educational experience?

[ ] What was your high school like?

[ ] How well did you do in high school?

[ ] What were some of your extra-curricular activities? (clubs, sports, jobs, etc.)

[ ] Did you achieve any accomplishments or special recognition?

[ ] What was your college like?

[ ] How big a school was it?

[ ] What did you major in? Minor?

[ ] Where did you live during college?

[ ] Did you have to work your way through college?

[ ]    What kind of job did you have?

[ ]    What was life like on campus?

[ ]    Has your college degree helped your career?

[ ]    Do you have any thoughts about education that you would like to pass on to your children?

*(Additional Questions)*

[ ]    _____

[ ]    _____

### Let's Talk About Your HEALTH

[ ]    Did you ever have a serious health problem?

[ ]    Can you tell us how it started?

[ ]    How did it affect you?

[ ]    How long did it last?

[ ]    Did you ever have any physical disability?

[ ]    How did it occur?

[ ]    What influence did it have on your life?

[ ]    Did you ever have a close call with death?

[ ]    Do you wish to share any thoughts about the circumstances?

*(Additional Questions)*

[ ] _____

[ ] _____

### Let's Talk About Your RELATIVES

[ ]  Who are (were) your favorite relatives?

[ ]  Whom do (did) you most admire and why?

[ ]  Do you still live close to any relatives? Who?

[ ]  How often do you visit with your relatives?

[ ]  Do you have any special memories related to these visits?

[ ]  Did any relative particularly influence you?

[ ]  In what way?

[ ]  Do you have god-parents?

[ ]  What are their names and what can you tell us about them?

[ ]  Would you like to share any memories about the loss of a relative?

[ ]  Did you ever enter into business or other venture with any of your relatives?

[ ]   How did the business relationship affect your personal one?

*(Additional Questions)*

[ ]   _____

[ ]   _____

## Let's Talk About Your HOMES and WHERE YOU LIVED

[ ]   Can you list chronologically the places where you resided and when?

[ ]   What was your favorite house and its location?

[ ]   Are there any special circumstances relating to where you lived or why you lived there?

[ ]   Do you have any special memories connected with a particular home or place of residence?

[ ]   When did you move out of your parent's house?

[ ]   Did you live by yourself or have roommates?

[ ]   Did other family members outside your immediate family ever reside with you?

[ ]   What was that like?

[ ]   What do you remember about any of your neighbors?

*(Additional Questions)*

[ ]   _____

[ ]   _____

### Let's Talk About Your MARRIAGE

[ ]   How did you meet your spouse? Where?

[ ]   What were your first impressions of him/her?

[ ]   Did you suspect that he/she would be the "right" person?

[ ]   When did you actually fall in love?

[ ]   Were there any special circumstances?

[ ]   Where and when did you (your spouse) propose?

[ ]   How did you feel about getting married?

[ ]   How did your parents feel?

[ ]   What was your maiden name?

[ ]   When and where did you get married?

[ ]   What kind of a wedding did you have and how many people attended?

[ ]   Who were the best man and maid of honor?

[ ]   Where did you spend your honeymoon?

[ ]     What do you remember about it?

[ ]     Do you have any special wedding memories?

[ ]     Do you get along with your in-laws?

[ ]     Does your spouse get along with your family?

[ ]     How long have (had) you been married?

[ ]     When did your spouse pass away?     Where?

[ ]     How did it happen?

[ ]     Did you remarry?  To whom, where & when?

[ ]     Do you have any special thoughts or advice you would like to share about marriage?

*(Additional Questions)*

[ ]     _____

[ ]     _____

### Let's Talk About Your EMPLOYMENT HISTORY

[ ]     What was your first job and how did you get it?

[ ]     How old were you?

[ ]     What were your responsibilities?

[ ] Did you like it?

[ ] What do you do now?

[ ] How long have you been doing it?

[ ] What were you doing when you retired?

[ ] How old were you?

[ ] Was there anyone who particularly influenced your career choice?

[ ] Can you describe chronologically other jobs that you have had?

[ ] Were you ever unemployed for a period of time?

[ ] What were the circumstances?

[ ] How did that affect your life?

[ ] Was any job particularly influential in bringing about change in your life?

[ ] In what way?

[ ] What is your fondest job memory?

[ ] What was your most frustrating job related experience?

[ ] What was the best job you ever had and why?

[ ] What was the worst job you ever had and why?

[ ] Do you have any special memories or stories about your jobs or employers?

*(Additional Questions)*

[ ]   _____

[ ]   _____

### Let's Talk About Your MILITARY EXPERIENCES

[ ]   How many years did you spend in military service?

[ ]   Which years?

[ ]   Were you drafted or did you enlist?

[ ]   If you enlisted, what made you decide to do so?

[ ]   In which branch of the service did you serve?

[ ]   Where were you stationed?

[ ]   What was you highest rank?

[ ]   How did you earn your promotion?

[ ]   How did your military enlistment affect your home life?

[ ]   Did you serve in any wars?

[ ]   Which ones?

[ ]   Did you see any action?

[ ]   Where and when?

[ ] What can you tell us about those experiences?

[ ] How did the war affect your:

[ ] business?

[ ] family?

[ ] residence?

[ ] outlook on life?

[ ] What do you remember most about the threat of war?

[ ] What was the political climate of your community like prior to the war?

[ ] Did it change afterwards?

[ ] Did you have any relatives who were killed in a war?

[ ] How did you and your family deal with that tragedy?

[ ] Did you have any friends who were killed in a war?

[ ] How did that affect you?

[ ] Did you have any close calls with death during the war?

[ ] What is your most memorable military experience?

*(Additional Questions)*

[ ]    _____

[ ]    _____

## Let's Talk About Your RELIGION

[ ]    What religion are you?

[ ]    Were you raised this way?

[ ]    If not, what were you raised and why did you change?

[ ]    What role has religion played in your life?

[ ]    Were your parents actively religious?

[ ]    What did your parents teach you about religion?

[ ]    What formal religious schooling did you have?

[ ]    Did you take an active role in your church, synagogue, or place of worship?

[ ]    What were your favorite religious holidays and why?

[ ]    What kind of religious activities does your family participate in?

[ ]    Has anyone particularly influenced your religious beliefs? How?

[ ]　Have you had any special religious experiences that you would like to share?

[ ]　Have you ever experienced any religious prejudice?

[ ]　Can you tell us about it and when and where it occurred?

[ ]　How did it affect you?

[ ]　Do you think religion has changed since you were a child?  How?

[ ]　Do you think it is important for your children and grandchildren to be religiously active?

[ ]　What message would you like to give to your future generations regarding religion?

*(Additional Questions)*

[ ]　_____

[ ]　_____

## Let's Talk About Your FRIENDS

[ ]　Who are (were) your closest friends?

[ ]　Where, when and how did you meet?

[ ]　Can you tell us about the last time you saw them?

[ ]     How often do you see your best friends?

[ ]     Where do they live now?

[ ]     What kinds of things do (did) you like to do together?

[ ]     What do (did) you like or admire most about your closest friend?

[ ]     What was the nicest thing a friend ever did for you?

[ ]     What was the nicest thing you ever did for a friend?

[ ]     Did you ever lose a close friend because of a disagreement, misunderstanding, or business falling-out?

[ ]     What is the most important thing you have learned from a friend?

*(Additional Questions)*

[ ]     _____

[ ]     _____

## *Let's Talk A Little About YOURSELF*

[ ]     What makes you happiest?

[ ]     What really annoys you?

[ ]    What concerns you right now most about:

[ ]        yourself?

[ ]        your family

[ ]        your country?

[ ]        the world in which we live?

[ ]    Have you ever rebelled against something or some one?

[ ]    What is your strongest point?

[ ]    What is your weakest point?

[ ]    What are you most proud of?

[ ]    What are you most ashamed of?

[ ]    How have you most changed throughout the years?

[ ]    If you could go back and change anything, what would it be?

[ ]    Do you have a favorite joke you would like to tell?

*(Additional Questions)*

[ ]    _____

[ ]    _____

## Let's Talk About Your PERSONAL ACCOMPLISHMENTS or SPECIAL RECOGNITION

[ ]   What was the most prestigious public recognition that you have received?

[ ]   How old were you at the time?

[ ]   Who gave you this recognition?

[ ]   Were any of your family members present?

[ ]   How did they respond?

[ ]   What is your fondest memory of a personal or non-public recognition?

[ ]   Who gave you this recognition?

[ ]   Where did it take place?

[ ]   How old were you?

[ ]   Did you ever do something for which you think you deserved special recognition, but did not receive it?

[ ]   How did you feel at the time?

[ ]   How do you feel now about it?

[ ]   What would you say is your greatest or most satisfying personal accomplishment?

[ ]   Is there anything special on which you are currently working?

[ ]   What would you still like to accomplish?

*(Additional Questions)*

[ ] _____

[ ] _____

### *Let's Talk About Your RECREATION and LEISURE*

[ ] What do you most like to do for fun?

[ ] Has this always been true?

[ ] How do you like to relax?

[ ] What are your favorite hobbies?

[ ] What sports do (did) you play? When?

[ ] With whom do you spend most of your spare time?

[ ] What is your favorite TV show?

[ ] What is your favorite movie?

[ ] What is your favorite book?

*(Additional Questions)*

[ ] _____

[ ] _____

## *Let's Talk About Your SPECIAL FAMILY OCCASIONS*

[ ]    What was you favorite family occasion?

[ ]    When was it?

[ ]    Who was there?

[ ]    What happened?

[ ]    What was the funniest thing that happened at a family occasion?

[ ]    What was the most difficult family occasion you ever attended?

[ ]    What was the worst family occasion you ever attended?

[ ]    When was the last time you had a large family gathering?

[ ]    Do you recall anything special about it?

[ ]    What is the next family occasion you look forward to?

*(Additional Questions)*

[ ]    _____

[ ]    _____

*Let's Talk About the People, Places and/or Events*
*that have had a SPECIAL INFLUENCE on Your Life*

[ ] What person has had the most influence on you?

[ ] In what way have they influenced you?

[ ] Have you ever let them know how much they influenced you?

[ ] Was there any event during your childhood that had a special influence on your adult life?

[ ] school related?

[ ] friend related?

[ ] parent related?

[ ] discipline related?

[ ] vacation related?

[ ] other?

[ ] What particular place has had an important influence on you?

[ ] Can you describe it?

[ ] What makes that place special?

[ ] At what time in your life were you influenced by it?

[ ] Do you still visit it?

[ ]    Did any historical or political event have a par-
ticularly special influence on you?

[ ]    When did the event occur?

[ ]    Where were you at the time?

[ ]    What do you remember about:

[ ]        the Great Depression?

[ ]        the 1st World War?

[ ]        the 2nd World War?

[ ]        other recent or current wars?

[ ]        the first time you rode in a boat? train?
car? bus? etc.

[ ]        the first time you flew in an airplane?

[ ]        the first time you saw TV?

[ ]        the assassination of, or attempts to ass-
assinate U.S. presidents or other world
leaders?

[ ]        the first man on the moon?

[ ]        the first time you drove a car?

[ ]    Have you been particularly influenced by any
new inventions, space exploration, medical
discoveries or breakthroughs in scientific
research?

[ ]    Can you describe them?

[ ]    How did they change your life?

[ ] Have you ever experienced any natural disasters such as earthquakes, hurricanes, fires, etc. that had an impact on your life?

[ ] Can you describe what happened?

[ ] What do you think was the most important event during your lifetime and why?

*(Additional Questions)*

[ ] _____

[ ] _____

## *Do You Have Any SPECIAL MESSAGE or PERSONAL PHILOSOPHY that You Would Like To Share With Future Generations of Your Family?*

[ ] Is there anything else you would like to say that you forgot to mention earlier?

[ ] Are there any particular hopes or wishes that you have for your family that you would like to mention?

[ ] Is there a moral by which you have tried to live your life?

[ ] What do you think is the key to happiness?

[ ] When you think of the future, what do you see?

[ ] What closing message would you like to give?

# 10  DISCOVERING "OTHER" FAMILY ROOTS

## PLACES TO LOOK FOR MORE FAMILY HISTORY

The best place to find more about your family history is to start looking through family and *personal records*. Scan the attic, basement, closets, and desk drawers for items such as photographs and photo albums, scrap books, newspaper clippings, journals, diaries, old bills, and letters.

Be alert for deeds, mortgages, contracts, wills, and any other *legal papers*.

*Vital records* such as birth certificates, marriage certificates, and death certificates are excellent sources of family information.

Many families keep records in Bibles and have other church or other affiliated *religious records* such as confirmations, bar mitzvahs, or baptisms.

Federal, state, and local *government records* are other good sources of information. Look for income tax statements, passports, licenses, military papers, and citizenship papers.

Diplomas, school yearbooks, old tests and essay papers, report cards, achievement awards, and other

*academic records* provide an interesting background on family members.

You can also find valuable background in *health-related records* such as medical bills and health and life insurance policies.

If you are willing to do some serious searching, you can also obtain copies of the original *government censuses* and *immigration records* which have your ancestors listed in them! These usually include information such as addresses, occupations, and names of family members.

# FEDERAL ARCHIVES AND RECORD CENTERS

CALIFORNIA
Archives Branch
Federal Archives and Records Center
2400 Azila Rd.
Laguna Niguels, CA 92677
(714) 831-4220

Archives Branch
Federal Archives and Records Center
1000 Commodore Dr.
San Brono, CA 94066
(415) 876-9001

COLORADO
Archives Branch
Federal Archives and Records Center
Bldg. 48
Denver Federal Center
Denver, CO 80225
(303) 234-5271

DISTRICT OF COLUMBIA
The National Archives
8th & Constitution Aves.
Washington, DC 20408
(202) 523-3134

GEORGIA
Archives Branch
Federal Archives and Records Center
1557 St Joseph Ave.
East Point, GA 30344
(404) 763-7477

ILLINOIS
Archives Branch
Federal Archives and Records Center
7358 S. Pulaski Rd.
Chicago, IL 60629
(312) 353-0161

MASSACHUSETTS
Archives Branch
Federal Archives and Records Center
380 Trapeio Rd.
Waltham, MA 02154
(617) 894-2400

MISSOURI
Archives Branch
Federal Archives and Records Center
2306 E. Bannister Rd.
Kansas City, MO 64131
(816) 926-7271

NEW JERSEY
Archives Branch
Federal Archives and Records Center
Bldg. 22, MOT
Bayonne, NY 07002
(201) 858-7251

NEW YORK
U.S. Military Archives
U.S Military Academy
West Point, NY 10996

PENNSYLVANIA
Archives Branch
Federal Archives and Records Center
5000 Wissahickon Ave.
Philadelphia, PA 19144
(215) 951-5591

TEXAS
Archives Branch
Federal Archives and Records Center
4900 Hemphill St. Bldg. 1
Forth Worth, TX 76115
(817) 334-5525

WASHINGTON
Archives Branch
Federal Archives and Records Center
6125 San Point Way NE
Seattle, WA 98115
(206) 442-4502

# GENEALOGICAL SOCIETIES & ASSOCIATIONS

The Acadian Genealogical & Historical Society
of New Hampshire
52 Concord St.
Manchester, NH 03101
(603) 888-6215

Arizona State Genealogical Society
Box 42075
Tucson, AZ 85733

California Genealogical Society
2099 Pacific Ave.
San Francisco, CA 94109
(415) 567-1848

Chicago Genealogical Society
Box 1165
Chicago, IL 60690

Connecticut Society of Genealogists, Inc.
2906 Main St.
Glautonbury, CT 06033
(203) 633-4203

Dallas Genealogical Society
Box 12648
Dallas, TX 75225

Genealogical Society of Utah
50 E. North Temple St.
Salt Lake City, UT 84150
(801) 531- 2331

Iowa City Genealogical Society
Box 822
Iowa City, IA 52244

Kentucky Genealogical Society
Box 153
Frankfort, KY 40602
(502) 223-7541

Louisiana Genealogical & Historical Society
Box 3454
Baton Rouge, LO 70821

Massachusetts Society of Mayflower
Descendants
312 Statler Office Bldg.
Boston, MA 02116
(617) 426-1420

Midwest Historical & Genealogical Society
952 S. Hillside
Wichita, KS 67201

Minnesota Genealogical Society
Box 513
Biloxi, MI 39533
(601) 388-5576

National Genealogical Society
1921 Sunderland Pl. NW
Washington, DC 20036
(202) 785-2123

New York Genealogical & Biographical Society
122 E. 58th St.
New York, NY 10022
(212) 755-8532

North Carolina Genealogical Society
Box 1492
Raleigh, NC 27602
(704) 633-3575

Northeast Mississippi Historical &
Genealogical Society
Box 434
Tupelo, MS 38801

Northeastern Michigan Genealogical Society
491 Johnson St.
Alpena, MI
(517) 354-8728

Northwest Georgia Historical &
Genealogical Society
Box 2484
Rome, GA 30161

Polish Genealogical Society, Inc.
984 Milwaukee Ave.
Chicago, IL 60611
(312) 586-4242

St Louis Genealogical Society
1695 Brentwood Blvd.
Suite 203
St. Louis, MO 63144
(314) 968-2763

South Carolina Genealogical Society
11 Beverly Rd.
Columbia, SC 29407
(803) 766-1476

South Central Nebraska Genealogical Society
Rt. 2 Box 57
Minden, NE 68959

Southeastern Texas Genealogical &
Historical Society
695 Pearl St.
Box 3827
Beaumont, TX 77704

Southern California Genealogical Society
600 S. Central Ave.
Glendale, CA 91204

Southern Kentucky Genealogical Society
1717-B Canton Dr.
Bowling Green, KY 42101
(502) 843-1477

Texas State Genealogical Society
220 W. 22nd St.
Houston, TX 77018

Virginia Genealogical Society
Box 7469
Richmond, VA 23221
(807) 770-2306

Wisconsin State Genealogical Society
2109 20th Ave.
Monroe, WI 53566

# STATE BUREAUS OF VITAL STATISTICS

ALABAMA
Bureau of Vital Statistics
State Department of Health
Montgomery, AL 36104

ALASKA
Bureau of Vital Statistics
State Department of Health and Welfare
State Office Building
Juneau, AK 99801

ARIZONA
Bureau of Vital Statistics
State Board of Health
Phoenix, AZ 85007

ARKANSAS
Bureau of Vital Statistics
State Department of Health
4815 W. Markam St.
Little Rock, AR 72201

CALIFORNIA
Bureau of Vital Statistics and
Data Processing
State Department of Public Health
631 J St.
Sacramento, CA 95814

COLORADO
Records and Statistics Section
State Department of Health
4210 E. 11th Ave.
Denver, CO 80220

CONNECTICUT
Public Health Statistics Section
State Department of Health
79 Elm St.
Hartford, CT 06115

DELAWARE
Bureau of Vital Statistics
State Board of Health
Box 637
Dover, DE 19901

DISTRICT OF COLUMBIA
D.C. Department of Public Health
Vital Records Division
300 Indiana Ave. NW
Washington, DC 20001

FLORIDA
Bureau of Vital Statistics
State Department of Health
Box 210
Jacksonville, FL 32201

GEORGIA
Vital Records Service
State Department of Public Health
47 Trinity Ave. SW
Atlanta, GA 30334

HAWAII
State Department of Health
Research and Statistics Office
Box 3378
Honolulu, HA 96801

IDAHO
State Department of Health
Bureau of Vital Statistics
Boise, ID 83707

ILLINOIS
Department of Public Health
Bureau of Vital Records
525 W. Jefferson St.
Springfield, IL 62706

INDIANA
Division of Vital Records
State Board of Health
1330 W. Michigan St.

IOWA
Division of Records and Statistics
State Department of Health
Des Moines, IA 50319

KANSAS
State Department of Health,
Division of Vital Statistics
Records Section
Topeka, KS 66612

KENTUCKY
Office of Vital Statistics
State Department of Health
275 E. Main St.
Frankfort, KY 40601

LOUISIANA
Division of Public Health Statistics
State Department of Health
Box 60630
New Orleans, LA 70160

MAINE
Office of Vital Statistics
State Department of Health and Welfare
State House
Augusta, ME 04330

MARYLAND
Division of Vital Records
State Department of Health
State Office Building
310 West Preston St.
Baltimore, MD 21201

MASSACHUSETTS
Office of the Secretary of State
Division of Vital Statistics
272 State House
Boston, MA 02133

MICHIGAN
Vital Records Section
Michigan Department of Health
3500 N. Logan St.
Lansing, MI 48914

MINNESOTA
Section of Vital Statistics
State Department of Health
350 State Office Building
St. Paul, MN 55101

MISSISSIPPI
State Board of Health
Vital Records Registration
Box 1700
Jackson, MS 39205

MISSOURI
Vital Records
Division of Health
State Department of Public Health and Welfare
Jefferson City, MO 65101

MONTANA
Division of Records and Statistics
State Department of Health
Helena, MT 50601

NEBRASKA
Bureau of Vital Statistics
State Department of Health
Box 94757
Lincoln, NE 68509

NEVADA
Department of Health, Welfare, and
Rehabilitation
Division of Health
Section of Vital Statistics
Carson City, NV 89701

NEW HAMPSHIRE
State Department of Health and Welfare
Bureau of Vital Statistics
61 S. Spring St.
Concord, NH 03301

NEW JERSEY
State Department of Health
Bureau of Vital Statistics
Box 1540
Trenton, NJ 08625

NEW YORK
Bureau of Vital Records
State Department of Health
84 Holland Ave.
Albany, NY 12208

NORTH CAROLINA
Office of Vital Statistics
State Board of Health
Box 2091
Raleigh, NC 27602

NORTH DAKOTA
Division of Vital Statistics
State Department of Health
17th Floor
State Capitol
Bismark, ND 58501

OHIO
Division of Vital Statistics
State Department of Health
65 S. Front St.
G-20 State Department Building
Columbus, OH 43215

OKLAHOMA
Division of Statistics
State Department of Health
3400 N. Eastern Ave.
Oklahoma City, OK 73105

OREGON
Vital Statistics Section
State Board of Health
Box 231
Portland, OR 97207

PENNSYLVANIA
Division of Vital Statistics
State Department of Health
Box 90
Harrisburg, PA 17120

RHODE ISLAND
Division of Vital Statistics
State Department of Health
Room 351
State Office Building
101 Smith St.
Providence, RI 02903

SOUTH CAROLINA
Bureau of Vital Statistics
State Board of Health
J. Marion Sims Building
Columbia, SC 29201

SOUTH DAKOTA
Division of Public Health Statistics
State Department of Health
Pierre, SD 57501

TENNESSEE
Division of Vital Records
State Department of Health
Cordell Hull Building
Nashville, TN 37219

TEXAS
Office of Vital Statistics
State Department of Health
410 E. 5th St.
Austin, TX 78701

UTAH
Division of Vital Statistics
44 Medical Dr.
Salt Lake City, UT 84113

VERMONT
Vital Records Department
Secretary of State
State House
Montpelier, VT 05602

VIRGINIA
Bureau of Vital Statistics
State Department of Health
James Madison Building
Box 1000
Richmond, VA 23208

WASHINGTON
Bureau of Vital Statistics
State Department of Health
Public Health Building
Olympia, WA 98501

WEST VIRGINIA
Division of Vital Statistics
State Department of Health
State Office Building #3
Charleston, WV 25305

WISCONSIN
Bureau of Health Statistics
Wisconsin Division of Health
Box 309
Madison, WI 53701

WYOMING
Division of Vital Statistics
State Department of Health
State Office Building
Cheyenne, WY 82001

# ABOUT THE AUTHORS

Recognizing a growing interest in both home video and genealogy, in 1985 the authors developed the concept for VIDEO FAMILY PORTRAITS. Combining their video production and television interview skills, they began test marketing the video service in the Washington, D.C. area. Since then, public response to the idea of video taping family history and experiences has been overwhelmingly enthusiastic. With numerous individuals wanting to know more about how to "do it themselves," the authors compiled all of the necessary video and interviewing techniques in an easy-to-use book.

**Rob Huberman** formed his own media production and marketing business, Communication Techniques, in Washington, D.C. in 1978. Mr. Huberman has produced and directed television programs for education, entertainment, public relations, news, and public affairs, and has received several awards for programming excellence. He first entered the video field in 1968 as a television cameraman and later earned his B.A. in Communication in 1974 from The American University in Washington, D.C.

Mr. Huberman has taught television production courses in studio production, field production, and editing at the elementary, high school, and adult levels. He currently is a member of the Board of Directors of Arlington Community Television in Arlington, Va. and is a member of the National Genealogical Society.

**Laura Janis** was formerly with the Washington, D.C. Bureau of Cable News Network, where she assisted in the production of the morning news.    She also produced a cable television music entertainment series.

Ms. Janis' experience includes interviews she has conducted with government officials, public school administrators, and advocacy group representatives in the Nation's Capital.    She has researched and written public relations materials on special topics such as housing and real estate development, energy resources, environment and women's issues; and has been published in a sociological journal.

Ms. Janis earned her B.A. in English from the University of California at Berkeley in 1982 and is a graduate of the Publishing Procedures Program at Radcliffe, Harvard University.    She is currently a masters candidate in social work at the Catholic University of America in Washington, D.C.

VIDEO FAMILY PORTRAITS
# FAMILY INTERVIEW #2

SUBJECT'S NAME

INTERVIEWER'S NAME

DATE(S) OF INTERVIEW

PLACE OF INTERVIEW

## LET'S ASK SOME QUESTIONS!

### *HELPFUL HINT*
*Review the Family Interview Guide with the subject and mark those questions which you will discuss during the interview with an "X". Make any changes or additions which are appropriate. YOU DO NOT HAVE TO ANSWER EVERY QUESTION.*

## SAMPLE WARM-UP CONVERSATION

(Make a test video recording during the warm up.)

*Hello. You are looking nice for your recording.*

*We are about to begin the interview session which will cover the questions we discussed and selected beforehand.*

*Is that agreeable to you? Are you comfortable? Is there anything I can get you?*

(Stop the test recording)

*Now we will playback the tape just to make sure that everything is working properly.*

(Make a final tape check.)

*Everything looks fine. If you are ready, let's begin.*

(Make sure tape is recording)

## INTRODUCTION

[ ]    *Today is:* (day, month, date, year)

[ ]    *We are at*: (place of interview)

[ ]    *My name is:* (name of interviewer)

[ ]    *We are about to make a VIDEO FAMILY POR-TRAIT.*

### Let's Introduce Our Special Guest

[ ]    What is your full name.

[ ]    In what year were you born?

[ ]    Where were you born?

[ ]    How old are you now?

[ ]    Where do you currently live?

*(Additional Questions)*

[ ]    _____

[ ]    _____

### Let's Talk About Your FAMILY ROOTS

[ ]    What country(s) and city(s) did your ancestors come from prior to settling in the United States?

[ ] What can you tell us about the lives of these people before they arrived in this country?

[ ] What were their occupations?

[ ] What brought them to this country?

[ ] How did they get here?

[ ] Do you know in what year they settled?

[ ] Where did they settle?

[ ] Can you tell us why they chose to settle there?

[ ] What were the names of each of the individuals who first came to this country?

[ ] What were their relationships to each other?

[ ] What do you know about any of their other relatives?

[ ] Can you describe any of their extended family, such as aunts, uncles, or cousins?

[ ] How did their lives change after they arrived:

[ ] economically?

[ ] socially?

[ ] politically?

[ ] religiously?

[ ] occupationally?

[ ] family-wise?

[ ] How many generations of your family have lived in this country?

[ ] Do you have any special stories or recollections that you would like to share about your ancestors?

*(Additional Questions)*

[ ] _____

[ ] _____

## Let's Talk About Your PARENTS

[ ] What is your father's full name?

[ ] When was he born? Where?

[ ] When did he die? Where?

[ ] How old was he when he died?

[ ] What did he look like in your earliest memories? (height, weight, hair color, eyes, complexion, etc.)

[ ] in your teenage years?

[ ] in your adult years?

[ ] What can you tell us about his current or last occupation?

[ ] Where and when did he pursue his occupation?

[ ]   Did he ever change occupations?

[ ]   Can you tell us about them?

[ ]   What is your mother's name and maiden name?

[ ]   When was she born? Where?

[ ]   When did she die? Where?

[ ]   How old was she when she died?

[ ]   What did she look like in your earliest memories?     (height, weight, hair color, eyes, complexion, etc.)

[ ]       in your teenage years?

[ ]       in your adult years?

[ ]   What can you tell us about her current or last occupation?

[ ]   Where and when did she pursue her occupation?

[ ]   Did she ever change occupations?

[ ]   Can you tell us about them?

[ ]   How, where, and when did your parents meet?

[ ]   At what age were they married and where?

[ ]   Was it the first marriage for each?

[ ]   If not, can you tell us about his or her previous ones?

[ ]   When did they have their first child?

[ ]   How many children did they have all together?

[ ]   What were your parents' feelings regarding discipline?

[ ]   How did your parents influence you concerning:

[ ]      religion?

[ ]      money?

[ ]      education?

[ ]      social values/morals?

[ ]      relating to other people?

[ ]      children?

[ ]      work?

[ ]      politics?

[ ]      marriage?

[ ]   What were some of your parents' hobbies or leisure activities?

[ ]   What can you tell us about some of your parents' special friends?

[ ]   Do you have any special stories or recollections about your parents that you would like to share?

*(Additional Questions)*

[ ]  _____

[ ]  _____

### Let's Talk About Your CHILDHOOD

[ ]  Did you grow up primarily in one area?

[ ]  Did you move around a lot growing up?

[ ]  Did you like it and how did it affect your childhood?

[ ]  What was it like where you grew up?

[ ]  Were you:

[ ]      happy as a child?

[ ]      more introverted or extroverted?

[ ]      obedient or disobedient to your parents or authority?

[ ]      popular with other children?

[ ]  Who were some of your special friends?

[ ]  What can you tell us about your interests or activities?

[ ]  Did you ever have any health problems?

[ ] Tell us about any childhood special achievements, accomplishments, or recognition.

[ ] Who were your childhood role models or heroes?

[ ] Why did you identify with them?

[ ] Did you ever run away from home?

[ ] What happened?

[ ] Did your parents ever punish you? How?

[ ] Is there any particular childhood experience that dramatically changed your life?

[ ] What was dating like when you were a young adult?

[ ] When was the first time you fell in love?

[ ] Can you tell us about it?

[ ] What was your most memorable childhood experience?

[ ] What was your most frustrating childhood experience?

[ ] What was your most embarrassing childhood experience?

[ ] What did you want to be when you grew up?

[ ] Did you have any special travel experiences?

[ ] What was your fondest possession?

[ ] What did you always want that you never had?

[ ]   Who was the nicest person you ever knew?

[ ]   Who was the meanest person you ever knew?

[ ]   What are your fondest childhood memories?

*(Additional Questions)*

[ ]   _____

[ ]   _____

## Let's Talk About Your CHILDREN

[ ]   What are the full names of your children?

[ ]   When was each born?  Where?

[ ]   What are their current ages?

[ ]   Describe your memories during pregnancy and/or childbirth.

[ ]   Were all of your children planned?

[ ]   Did you lose any children?

[ ]   What happened?

[ ]   Did you find raising your children to be a difficult or easy task?

[ ]   What made it so?

[ ]   Did you have any extra help in raising your children?

[ ]   What were your most trying moments as a parent?

[ ]   What was your worst experience in raising a child?

[ ]   What was the funniest experience?

[ ]   What was the most rewarding experience?

[ ]   How did you discipline your children?

[ ]   How did children affect and/or change your:

[ ]      work?

[ ]      relationship with your spouse?

[ ]      relationship with your parents?

[ ]      outlook on life?

[ ]   Did you take family trips with the children?

[ ]      where and when?

[ ]      which was the most memorable?

[ ]   Did your children ever have any serious health problems? Please describe.

[ ]   Who was most responsible for disciplining your children?

[ ]   What did you think your children would become when they grew up?

[ ]  Did your children spend much time with any particular relatives?

[ ]  What are your fondest memories regarding your children?

[ ]  What makes you proudest about being a parent?

[ ]  Do you have any special thoughts you would like your children to remember about themselves?

*(Additional Questions)*

[ ]  _____

[ ]  _____

## Let's Talk About Being GRANDPARENTS

[ ]  When did you first become a grandparent?

[ ]  How did it make you feel?

[ ]  How old were you at the time?

[ ]  How many grandchildren do you now have?

[ ]  What are their names?

[ ]  What is best about being a grandparent?

[ ]  Do you have any great-grandchildren?

[ ]    What are their names?

[ ]    What can you tell us about being a great-grandparent?

[ ]    Do you have any special stories about your grandchildren that you would like to share?

*(Additional Questions)*

[ ]    _____

[ ]    _____

## Let's Talk About Your EDUCATION

[ ]    What was the name and location of your:

[ ]        grammar school?

[ ]        junior & senior high?

[ ]        college or university?

[ ]        post-graduate school?

[ ]        other schools? (vocational, special training)

[ ]    What was your grade school like?

[ ]    How did you get to school everyday?

[ ]    What were your favorite grade school subjects?

[ ]    What kind of student were you?

[ ] Did your parents help you with your school work?

[ ] Did you have any particularly influential or favorite teachers?

[ ] Who were your best school friends?

[ ] What are your best school memories?

[ ] Did you ever "play hooky" from school?

[ ] What did you do instead of going to school?

[ ] Did you ever get caught? What happened?

[ ] What was your worst educational experience?

[ ] What was your high school like?

[ ] How well did you do in high school?

[ ] What were some of your extra-curricular activities? (clubs, sports, jobs, etc.)

[ ] Did you achieve any accomplishments or special recognition?

[ ] What was your college like?

[ ] How big a school was it?

[ ] What did you major in? Minor?

[ ] Where did you live during college?

[ ] Did you have to work your way through college?

[ ]   What kind of job did you have?

[ ]   What was life like on campus?

[ ]   Has your college degree helped your career?

[ ]   Do you have any thoughts about education that you would like to pass on to your children?

*(Additional Questions)*

[ ]   _____

[ ]   _____

### Let's Talk About Your HEALTH

[ ]   Did you ever have a serious health problem?

[ ]   Can you tell us how it started?

[ ]   How did it affect you?

[ ]   How long did it last?

[ ]   Did you ever have any physical disability?

[ ]   How did it occur?

[ ]   What influence did it have on your life?

[ ]   Did you ever have a close call with death?

[ ]   Do you wish to share any thoughts about the circumstances?

*(Additional Questions)*

[ ] _____

[ ] _____

## Let's Talk About Your RELATIVES

[ ] Who are (were) your favorite relatives?

[ ] Whom do (did) you most admire and why?

[ ] Do you still live close to any relatives? Who?

[ ] How often do you visit with your relatives?

[ ] Do you have any special memories related to these visits?

[ ] Did any relative particularly influence you?

[ ] In what way?

[ ] Do you have god-parents?

[ ] What are their names and what can you tell us about them?

[ ] Would you like to share any memories about the loss of a relative?

[ ] Did you ever enter into business or other venture with any of your relatives?

[ ]   How did the business relationship affect your personal one?

*(Additional Questions)*

[ ]   _____

[ ]   _____

## Let's Talk About Your HOMES and WHERE YOU LIVED

[ ]   Can you list chronologically the places where you resided and when?

[ ]   What was your favorite house and its location?

[ ]   Are there any special circumstances relating to where you lived or why you lived there?

[ ]   Do you have any special memories connected with a particular home or place of residence?

[ ]   When did you move out of your parent's house?

[ ]   Did you live by yourself or have roommates?

[ ]   Did other family members outside your immediate family ever reside with you?
[ ]   What was that like?

[ ]   What do you remember about any of your neighbors?

*(Additional Questions)*

[ ] _____

[ ] _____

### Let's Talk About Your MARRIAGE

[ ]     How did you meet your spouse?  Where?

[ ]     What were your first impressions of him/her?

[ ]     Did you suspect that he/she would be the "right" person?

[ ]     When did you actually fall in love?

[ ]     Were there any special circumstances?

[ ]     Where and when did you (your spouse) propose?

[ ]     How did you feel about getting married?

[ ]     How did your parents feel?

[ ]     What was your maiden name?

[ ]     When and where did you get married?

[ ]     What kind of a wedding did you have and how many people attended?

[ ]     Who were the best man and maid of honor?

[ ]     Where did you spend your honeymoon?

[ ]   What do you remember about it?

[ ]   Do you have any special wedding memories?

[ ]   Do you get along with your in-laws?

[ ]   Does your spouse get along with your family?

[ ]   How long have (had) you been married?

[ ]   When did your spouse pass away?   Where?

[ ]   How did it happen?

[ ]   Did you remarry?  To whom, where & when?

[ ]   Do you have any special thoughts or advice you would like to share about marriage?

*(Additional Questions)*

[ ]   _____

[ ]   _____

### Let's Talk About Your EMPLOYMENT HISTORY

[ ]   What was your first job and how did you get it?

[ ]   How old were you?

[ ]   What were your responsibilities?

[ ] Did you like it?

[ ] What do you do now?

[ ] How long have you been doing it?

[ ] What were you doing when you retired?

[ ] How old were you?

[ ] Was there anyone who particularly influenced your career choice?

[ ] Can you describe chronologically other jobs that you have had?

[ ] Were you ever unemployed for a period of time?

[ ] What were the circumstances?

[ ] How did that affect your life?

[ ] Was any job particularly influential in bringing about change in your life?

[ ] In what way?

[ ] What is your fondest job memory?

[ ] What was your most frustrating job related experience?

[ ] What was the best job you ever had and why?

[ ] What was the worst job you ever had and why?

[ ] Do you have any special memories or stories about your jobs or employers?

*(Additional Questions)*

[ ] _____

[ ] _____

### Let's Talk About Your MILITARY EXPERIENCES

[ ] How many years did you spend in military service?

[ ] Which years?

[ ] Were you drafted or did you enlist?

[ ] If you enlisted, what made you decide to do so?

[ ] In which branch of the service did you serve?

[ ] Where were you stationed?

[ ] What was you highest rank?

[ ] How did you earn your promotion?

[ ] How did your military enlistment affect your home life?

[ ] Did you serve in any wars?

[ ] Which ones?

[ ] Did you see any action?

[ ] Where and when?

[ ]     What can you tell us about those experiences?

[ ]     How did the war affect your:

[ ]         business?

[ ]         family?

[ ]         residence?

[ ]         outlook on life?

[ ]     What do you remember most about the threat of war?

[ ]     What was the political climate of your community like prior to the war?

[ ]     Did it change afterwards?

[ ]     Did you have any relatives who were killed in a war?

[ ]     How did you and your family deal with that tragedy?

[ ]     Did you have any friends who were killed in a war?

[ ]     How did that affect you?

[ ]     Did you have any close calls with death during the war?

[ ]     What is your most memorable military experience?

*(Additional Questions)*

[ ]    _____

[ ]    _____

## Let's Talk About Your RELIGION

[ ]    What religion are you?

[ ]    Were you raised this way?

[ ]    If not, what were you raised and why did you change?

[ ]    What role has religion played in your life?

[ ]    Were your parents actively religious?

[ ]    What did your parents teach you about religion?

[ ]    What formal religious schooling did you have?

[ ]    Did you take an active role in your church, synagogue, or place of worship?

[ ]    What were your favorite religious holidays and why?

[ ]    What kind of religious activities does your family participate in?

[ ]    Has anyone particularly influenced your religious beliefs? How?

[ ] Have you had any special religious experiences that you would like to share?

[ ] Have you ever experienced any religious prejudice?

[ ] Can you tell us about it and when and where it occurred?

[ ] How did it affect you?

[ ] Do you think religion has changed since you were a child? How?

[ ] Do you think it is important for your children and grandchildren to be religiously active?

[ ] What message would you like to give to your future generations regarding religion?

*(Additional Questions)*

[ ] _____

[ ] _____

## Let's Talk About Your FRIENDS

[ ] Who are (were) your closest friends?

[ ] Where, when and how did you meet?

[ ] Can you tell us about the last time you saw them?

[ ]    How often do you see your best friends?

[ ]    Where do they live now?

[ ]    What kinds of things do (did) you like to do together?

[ ]    What do (did) you like or admire most about your closest friend?

[ ]    What was the nicest thing a friend ever did for you?

[ ]    What was the nicest thing you ever did for a friend?

[ ]    Did you ever lose a close friend because of a disagreement, misunderstanding, or business falling-out?

[ ]    What is the most important thing you have learned from a friend?

*(Additional Questions)*

[ ]    _____

[ ]    _____

## Let's Talk A Little About YOURSELF

[ ]    What makes you happiest?

[ ]    What really annoys you?

[ ]    What concerns you right now most about:

[ ]        yourself?

[ ]        your family

[ ]        your country?

[ ]        the world in which we live?

[ ]    Have you ever rebelled against something or some one?

[ ]    What is your strongest point?

[ ]    What is your weakest point?

[ ]    What are you most proud of?

[ ]    What are you most ashamed of?

[ ]    How have you most changed throughout the years?

[ ]    If you could go back and change anything, what would it be?

[ ]    Do you have a favorite joke you would like to tell?

*(Additional Questions)*

[ ]    _____

[ ]    _____

## *Let's Talk About Your PERSONAL ACCOMPLISHMENTS or SPECIAL RECOGNITION*

[ ]   What was the most prestigious public recognition that you have received?

[ ]   How old were you at the time?

[ ]   Who gave you this recognition?

[ ]   Were any of your family members present?

[ ]   How did they respond?

[ ]   What is your fondest memory of a personal or non-public recognition?

[ ]   Who gave you this recognition?

[ ]   Where did it take place?

[ ]   How old were you?

[ ]   Did you ever do something for which you think you deserved special recognition, but did not receive it?

[ ]   How did you feel at the time?

[ ]   How do you feel now about it?

[ ]   What would you say is your greatest or most satisfying personal accomplishment?

[ ]   Is there anything special on which you are currently working?

[ ]   What would you still like to accomplish?

*(Additional Questions)*

[ ]    _____

[ ]    _____

## Let's Talk About Your RECREATION and LEISURE

[ ]    What do you most like to do for fun?

[ ]    Has this always been true?

[ ]    How do you like to relax?

[ ]    What are your favorite hobbies?

[ ]    What sports do (did) you play?  When?

[ ]    With whom do you spend most of your spare time?

[ ]    What is your favorite TV show?

[ ]    What is your favorite movie?

[ ]    What is your favorite book?

*(Additional Questions)*

[ ]    _____

[ ]    _____

## *Let's Talk About Your SPECIAL FAMILY OCCASIONS*

[ ] What was you favorite family occasion?

[ ] When was it?

[ ] Who was there?

[ ] What happened?

[ ] What was the funniest thing that happened at a family occasion?

[ ] What was the most difficult family occasion you ever attended?

[ ] What was the worst family occasion you ever attended?

[ ] When was the last time you had a large family gathering?

[ ] Do you recall anything special about it?

[ ] What is the next family occasion you look forward to?

*(Additional Questions)*

[ ] _____

[ ] _____

### *Let's Talk About the People, Places and/or Events that have had a SPECIAL INFLUENCE on Your Life*

[ ] What person has had the most influence on you?

[ ] In what way have they influenced you?

[ ] Have you ever let them know how much they influenced you?

[ ] Was there any event during your childhood that had a special influence on your adult life?

[ ] school related?

[ ] friend related?

[ ] parent related?

[ ] discipline related?

[ ] vacation related?

[ ] other?

[ ] What particular place has had an important influence on you?

[ ] Can you describe it?

[ ] What makes that place special?

[ ] At what time in your life were you influenced by it?

[ ] Do you still visit it?

[ ] Did any historical or political event have a particularly special influence on you?

[ ] When did the event occur?

[ ] Where were you at the time?

[ ] What do you remember about:

[ ]     the Great Depression?

[ ]     the 1st World War?

[ ]     the 2nd World War?

[ ]     other recent or current wars?

[ ]     the first time you rode in a boat? train? car? bus? etc.

[ ]     the first time you flew in an airplane?

[ ]     the first time you saw TV?

[ ]     the assassination of, or attempts to assassinate U.S. presidents or other world leaders?

[ ]     the first man on the moon?

[ ]     the first time you drove a car?

[ ] Have you been particularly influenced by any new inventions, space exploration, medical discoveries or breakthroughs in scientific research?

[ ] Can you describe them?

[ ] How did they change your life?

[ ] Have you ever experienced any natural disasters such as earthquakes, hurricanes, fires, etc. that had an impact on your life?

[ ] Can you describe what happened?

[ ] What do you think was the most important event during your lifetime and why?

*(Additional Questions)*

[ ] _____

[ ] _____

### Do You Have Any SPECIAL MESSAGE or PERSONAL PHILOSOPHY that You Would Like To Share With Future Generations of Your Family?

[ ] Is there anything else you would like to say that you forgot to mention earlier?

[ ] Are there any particular hopes or wishes that you have for your family that you would like to mention?

[ ] Is there a moral by which you have tried to live your life?

[ ] What do you think is the key to happiness?

[ ] When you think of the future, what do you see?

[ ] What closing message would you like to give?

# NOTES

# NOTES

# NOTES

# NOTES